CHRIS DRURY

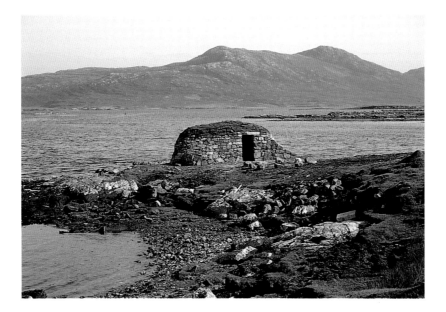

for

Beatrice

Larch

Rowan

and

Kay

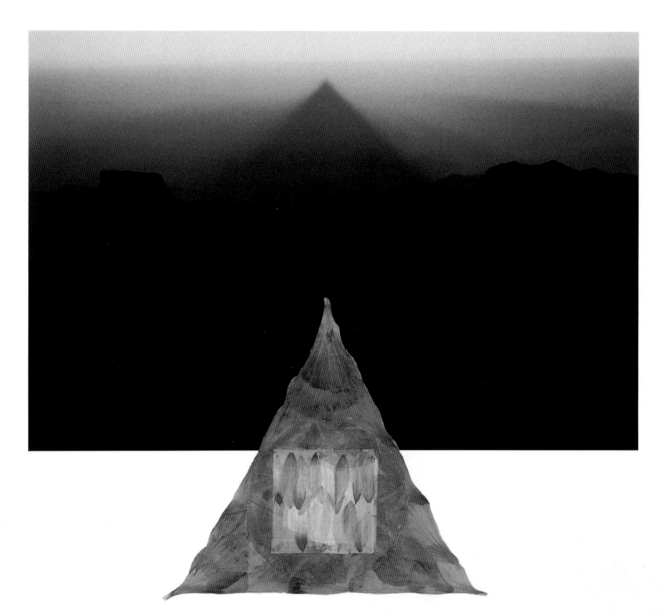

BUDDHA STANDING BUDDHA SITTING BUDDHA LYING DOWN

Taking petals from Adams Peak to Polonnaruwa and placing them at the feet of The Gal Vihare Sculptures
Sri Lanka 1987

CHRIS DRURY

FOUND MOMENTS IN TIME AND SPACE

Harry N. Abrams, Inc., Publishers

Produced by Jill Hollis and Ian Cameron
Cameron Books, Moffat, Dumfriesshire, Scotland

ISBN 0–8109–3246–6

Published in 1998 by Harry N. Abrams, Incorporated, New York

Printed and bound in Italy by Artegrafica, Verona

Harry N. Abrams, Inc.
100 Fifth Avenue
New York, N.Y. 10011
www.abramsbooks.com

Photo credits
Ace Contemporary Exhibitions pp.7 (left), 8, 12 (left), 13, 24 (top), 29, 31, 34, 35 (top), 40, 43
(bottom), 86, 87 (bottom), 101; Aldo Belmonte p.33; Alfio Bonanno p.81; Ian Cameron
endpapers, pp.5, 36 (right), 46, 47, 48, 50, 69, 79, 84, 90, 91, 92, 93, 94-95, 100 (top), 102
(bottom), 109, 114 (centre), 116 (bottom), 118 (bottom); Aldo Fedele p.106, 107; Neil Fletcher
pp.10 (left), 11, 12 (right), 53, 54, 63, 64 (bottom), 75, 77, 78; Philip Giles p.119; Hakushi
Maeda p.57 (top left, top right, bottom right); Rebecca Hossack p.111 (bottom right); Sean
Hudson jacket front, p.56; Irish Museum of Modern Art, Dublin p.85; Leeds Museums and
Galleries (City Art Gallery) p.19; Peter Macdiarmid p.111 (bottom left); Scottish Arts Council
p.99; Rodney Todd-White pp.90-91.

Other photographs, including all those taken in the landscape (some of which are photo works),
are the work of Chris Drury.

Endpapers

ALPS/JURA

woven maps

1995

page 1

HUT OF THE SHADOW

stone walls, timber and turf roof, mirrors, lens

North Uist, Scotland, 1997

page 2

PETALS

Cibachrome, flower petals, text

1987

Revered by five religions, Sri Pada is a 7,000-foot peak in the south of Sri Lanka, one of seven mountains in the world which project a pyramid shadow on the surrounding landscape at dawn. Pilgrims from all over the world make their way to its summit during three months each year. The rest of the time, apart from being home to a handful of Buddhist monks, it is the abode of elephants and leopards, and in April a blizzard of small yellow butterflies migrates to the peak, where they lay their eggs and then die.

In February 1987, I collected petals from three types of flower growing on the slopes of Sri Pada, pressed them in a book and walked to Polonarrua, the ancient, ruined Buddhist capital in the north, to place them at the feet of the three huge stone carvings of Buddha. I was both walking a Buddhist pilgrim route and retracing early childhood memories.

Opposite

BASKET FOR THE CROWS

hazel, willow, crow feathers

1986

CONTENTS

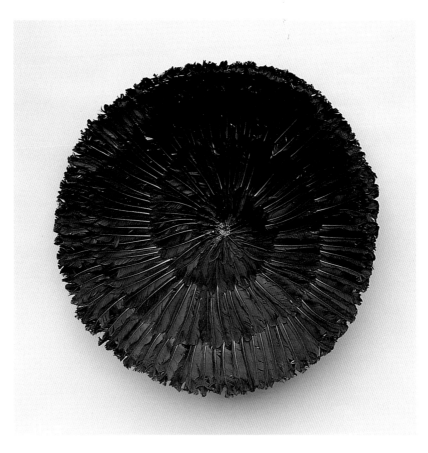

INTRODUCTION
Kay Syrad

The edge is the division.
What is known is always from the past.
Through knowledge the new is a reworking of the old.
The sum total of knowledge is culture.
Culture is the veil through which we describe nature.
The process of nature continues despite our analysis.
Our analysis is a part of the process of nature.
The process of nature must include the actions of man
whether or not they are destructive.
Man's description of 'nature' as something separate –
out of town – where the edge is the division
between 'nature' and 'culture', is an illusion
'Nature' and 'culture' are the same thing.
There is no division.

Chris Drury 1995

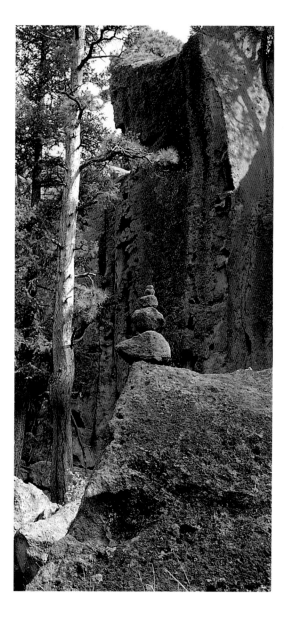

SCREAMING FOX CANYON CAIRN

New Mexico, 1993

Chris Drury's work over the last sixteen years constitutes a sustained exploration of the conceptual distinctions commonly made between nature and culture. His work is generally shown and categorised as 'Land Art' or 'Art in Nature', a context which, ironically, tends to maintain the divisions that he opposes. Drury does not seek to romanticise nature, although many of his works draw attention to nature's beauty; nor is he working from a political or moral position which imbues nature with goodness, to be protected from human badness. He is concerned, rather, with the knowledge and insight given to our 'inner nature', or consciousness, by certain types of encounter with 'outer nature', the material world. He wishes neither to romanticise art, nor to give it status above any other activity, and in this he is influenced by the tenets of Zen Buddhism:

'An artist is a communicator, but to be an artist one must first be a human being: that is to say, whole, undivided, if that is possible. From such a position there is no division between man, art and nature. The world is perceived as it is. Personally I have nothing to communicate, consciously, or unconsciously; the work simply reflects the moving from moment to moment in the world as it is, and so it is nature itself that communicates.'

Thus Drury makes objects that may not necessarily be perceived as art: shelters, constructed simply from whatever materials are to hand in a particular place; cairns, as signposts or markers; a basket as container; stone or wood chambers with an aperture at the top making a *camera obscura*, so that the outside is brought inside, creating a place for contemplation. 'Any aesthetic is minimalised and comes from need and the land', he says. Most of his works disintegrate, others he dismantles. Some, if they are unobtrusive, remain. The art lies in the ideas, in the process of making, in the judging of formal and spatial relationships, as well as in the assembled or made objects, which are often breathtaking in their beauty.

Drury has been working in this way since the 1970s. While living on the Romney Marshes in Kent, he met the artist Hamish Fulton. In 1974, the two travelled to Canada to walk in the

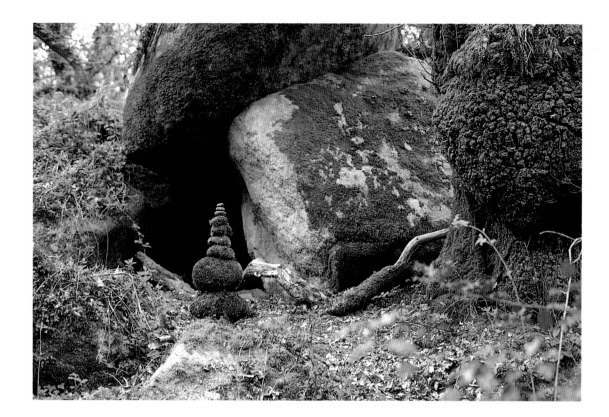

COYOTE DREAM

blackthorn branches, granite and resin

1980-1981

*Lucy R. Lippard, *Overlay: Contemporary Art and the Art of PreHistory*, Pantheon, New York, 1983, p.4.

Canadian Rockies. Fulton's work – his photographically documented walks in remote areas – was revolutionary at this time in its reassessment of our relationship with land and 'landscape'. Drury's experience with Fulton revealed to him a way of working with nature that was very different from his earlier, figurative sculpture (busts, animals, birds). In the act of walking in mountains, deserts, forests, through constant movement, in coping with wind, rain, snow, cold, fatigue, it becomes possible, Drury argues, to reach a state in which the inner and outer realities become a 'fluid whole'.

The artist is, for Drury, a 'welder of different realities', an interface between insight and communication, between insight and consciousness: 'Making art, for me, is never the means of finding insight. It is rather the reflection of a growing consciousness . . . I go to "outer nature", which is thought-less, void, in order to see the whole. From the void comes insight, which makes art.' Inner nature, by contrast, is made up of reveries, feelings, visions, dreams, memories, the constant chatter of the mind. Inner nature 'seeks to be whole, but encounters fear, greed, jealousy ambition, violence . . . which has brought about the divorce of man and nature.' Taking refuge from the bigness of open spaces in a small, cocooned shelter is the opposite of allowing the mountains to stretch you outside yourself beyond the next horizon. It is in the space and movement *between* the two that insight becomes possible.

Drury continued for a while to make representational work such as Coyote Dream (1980), where the coyote is a totem animal through which the desert landscape of Texas is perceived. In 1982, however, he made a decision not to make any more work of this kind: 'I wanted to see the world with openness, not from a fixed point of view. So I began using the very stuff of the world'. In the autumn of 1982-83, Drury made Medicine Wheel, a work composed of 365 natural objects, one for each day of the year, collected daily and strung between 24 spokes of an eight-foot wheel: 'In essence a calendar of chance, where objects were allowed to come to me rather than me consciously looking for objects. This piece was a critical turning point in my work.'

In her analysis of the dialectic between nature and culture, Lucy Lippard remarks that 'Art itself may be partially defined as an expression of that moment of tension when human intervention in, or collaboration with, nature, is recognised.'* Drury goes beyond this recognition to make that tension the subject of his work. Thus he exposes the dynamic between inner and outer nature,

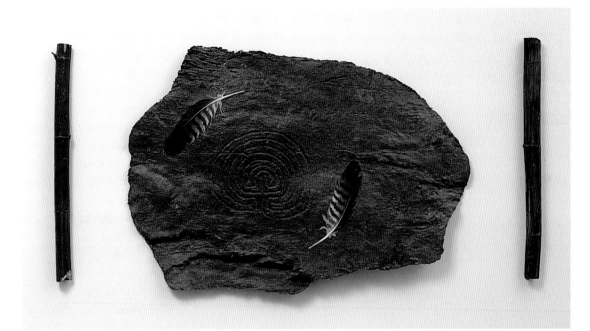

BUZZARD IN THE MIST

plant pulp cast from prehistoric stone carving
in St Nectan's Glen, Cornwall, *Polygonum* sticks, feathers
1984

between movement and stillness, between nearness and distance: he transforms a shelter into a basket, he builds a shelter inside a gallery, he builds a stone shelter inside an open-weave dome through which one views a mountain, he makes a whirlpool from stones in a riverbed.

David Reason, who has commented on Drury's sculpture over a number of years, writes compellingly about these works: 'The shelters (how touchingly small they usually are) and baskets transform anxiety into an ambivalent protectiveness, and evoke a matter-of-fact (and thus parental) tenderness.' He then concentrates on a particular series, In the Presence of the Forest Deer, in which a shelter constructed of heather branches and thatched with grass is later, when it is brought into the gallery, turned inside out: the shelter's thatch is reworked into a cone placed *inside* the 'gaunt framework' of the shelter. 'This doubling,' he observes, 'does not resolve the landscape artist's problem of bringing the outside inside, rather it dramatises it.'*

*David Reason, 'The World's Room: Shelters and Baskets: Gathering Place' in *Chris Drury: Shelters and Baskets*, Orchard Gallery, Derry, Ireland (1988).

It is precisely at the moment when these tensions are perceived that the nature of one's relationship to the material world is most transparent. In Drury's more recent cloud chamber series, for example, the uncontained outside is brought into a dark, contained space. The outside shrinks to the size of the rough, whitewashed floor or wall, on which it dances. We are like children in the presence of this magic lantern show – more enchanted with this simple transposition than with any amount of high-tech cyber-reality, perhaps *because* of its utter simplicity and its human scale. Thus we move from sophistication to innocence, and must, if only for a second, surrender to a new openness to the world, such as Drury himself has experienced.

A similar process is at work when Drury makes a piece which defies usual definitions and expectations. In the kayak works, for example, Drury uses a spacious, open weave, rather than a dense, closed one. The large kayak (Air Vessel), beautiful and technically perfect, is suspended from the ceiling. It is not capable of holding a person, it is not for sailing, it is not *for* flying, rather it *is* flying. This piece has the power to inspire, to offer hope, by forcing a surrender, temporarily, of the desire for rationality, for the practical or functional. The three miniature kayaks, in their reduced scale, and mounted vertically on the wall, also demand a reconsideration. All three are woven from willow, using a spiral weave that emulates the flow of water. One kayak is densely wrapped with willow bark, the other two are open. Two of the small kayaks have vertical struts, one has struts that run in a spiral. Side by side they invite speculation about shape and texture and movement in relation to their function in another time and place.

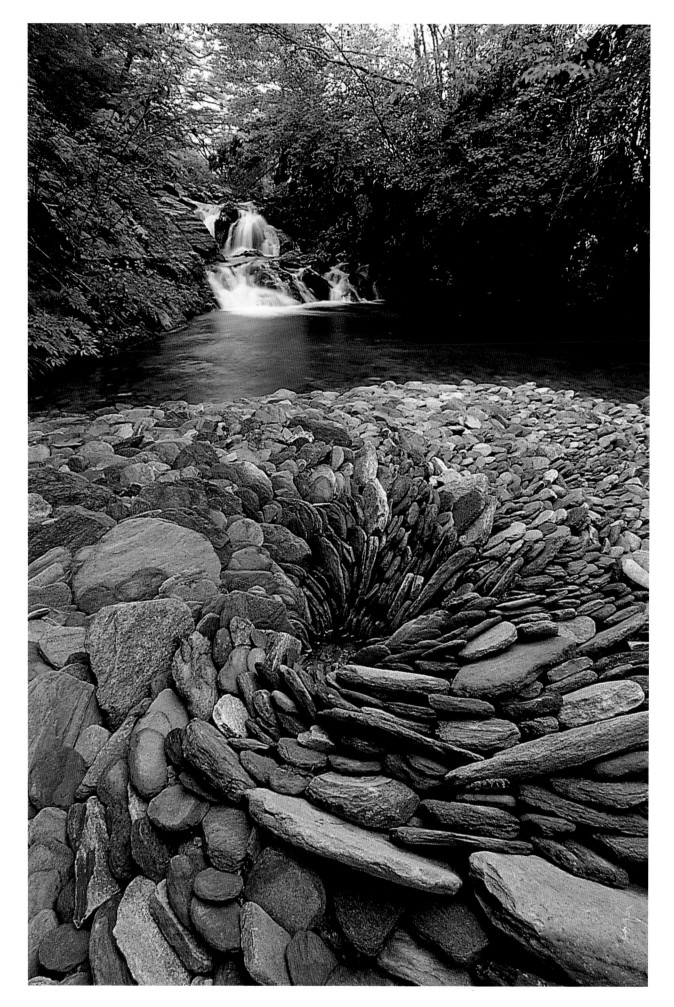

STONE WHIRLPOOL

Okawa-mura, Kochi Prefecture,

Japan, 1996

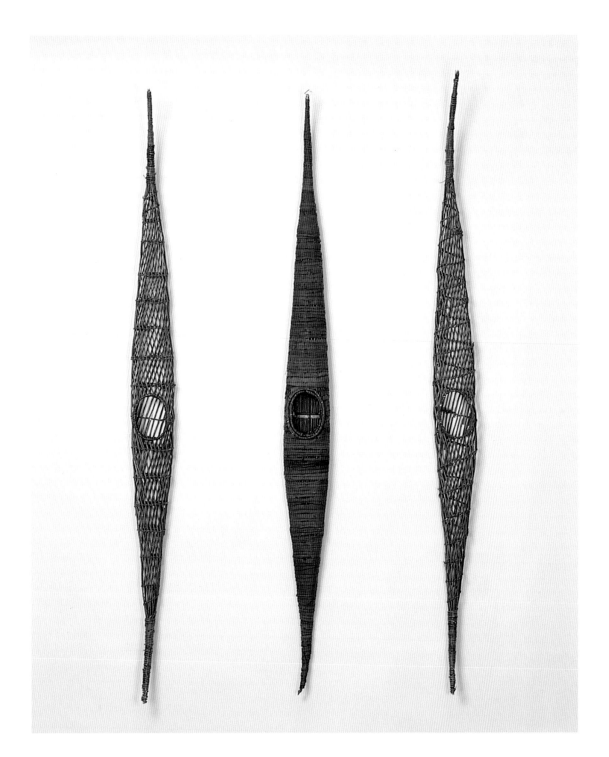

KAYAK BUNDLES

willow and willow bark

1994

Drury also has an interest in permanence and impermanence. In Zen, an understanding of the eternal movement of nature is essential to a respect for nature. Here, impermanence might also be called movement; permanence, stillness. In the cloud chambers, the chamber is (relatively) permanent, whilst the image inside is constantly changing. Because Drury uses materials such as wood, stone, dung, soil, mushrooms, most of his works eventually disintegrate. What is left, however, is the essence of a work, often in the minds of the people with whom Drury collaborated during a project. The physical object is impermanent; the labour performed by human bodies, and the memories, have permanence. There is a parallel here with the practice of Tibetan sand paintings, where monks spend weeks making a sand painting, focusing their attention on the image, not for its own sake, but for the purpose of healing or for the good of the community. Then they tip the sand into the river. What remains is not the image, but the symbolic strength of the collective focus of attention.

Drury's work is itself based on focused attention and physical labour. The element of labour, sometimes back-breaking, heavy toil, sometimes the close, monotonous labour of weaving, is something that distinguishes his work from that of his contemporaries in this field. For Drury, the process of making is revelatory: as the interface, he communicates the possibilities and limitations of nature. The final object is testimony to human labour interacting with the conditions and formations of the land, with the materials given by the land, and with the climate and weather.

It could be argued that Drury's work constitutes a challenge to western values that elevate art and demean craft. Craft is an integral part of his work. Some of his shelters are built in a random way, gathering whatever local materials are to hand, to make something that will be functional but imperfect, like a bird's nest. This randomness draws attention to the materials used, and to the place from which they come; here one is looking outwards. The more intricately woven baskets, kayaks and maps, however, display a knowledge of weaving techniques and patterns from across the world. These meticulous baskets are about ideas, recalling a dream, for example, or referring to how the world is ordered: this time, a looking inward.

*David Reason, 'Trying to see clearly: An angle of sunlight' in *Landscape: Place, Nature, Material*, Kettle's Yard, Cambridge, 1986, p.16.

Basket weaving is one of the most ancient crafts: the Buddha's last sermon was called *Sutta Pitaka, The Basket of Discourse*.* What attracted Drury to basket-weaving was reading that basket-makers of certain Native American tribes of the South West go through an apprenticeship to learn the craft, discovering not only how, when and where to collect the appropriate materials, but, ultimately, how to weave the psyche of the tribe into a basket. (Thus a basket commissioned for a wedding would embrace both the practical and the spiritual.) Drury is fascinated by that 'invisible something that has nothing to do with craft', a dimension that our culture appears largely to have lost. Basket-weaving is a job for the days of winter (a coil basket might take two months to make); it is repetitive, hypnotic, meditative. But, as with the heavy labour, it is transformative, because of the 'invisible something' that is brought to the making:

'I extend baskets further by plastering them with cow dung, to make open/closed series, or they become vessels to denote journeys, or as in Air Vessel, to denote moments of exhilaration on

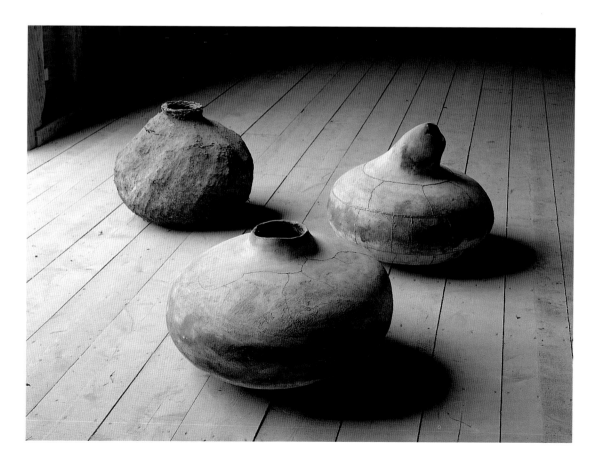

ALTERED VESSELS

willow with cow dung (*left*) and clay vessels which cracked apart during firing and were then glued together and lined with epoxy resin mixed with brass dust (*centre and right*)

1992

mountains where I have experienced a feeling akin to flying. Baskets and shelters are like two halves of a whole. The one is constantly becoming the other.'

The distinction between art and craft, here, breaks down, becomes irrelevant.

Jackson Pollock once said 'I *am* Nature . . . I work from the inside out, like nature.'* Drury starts from a different position: that nothing is added to our understanding by stating that we are, simply, all part of nature (although there is a sense in which this cannot be denied); for him to imagine that he works always or necessarily from the inside out, or outside in, would be to interrupt the dynamic between the two possibilities. He says, 'The self is like a swing door, between outside and inside, permitting a free flow from one to the other.' His relationship to the material world is spatial and sensuous. He allows the material world to come to him and he greets it: his greeting is manifest in shape and texture.

*Lippard, p.52

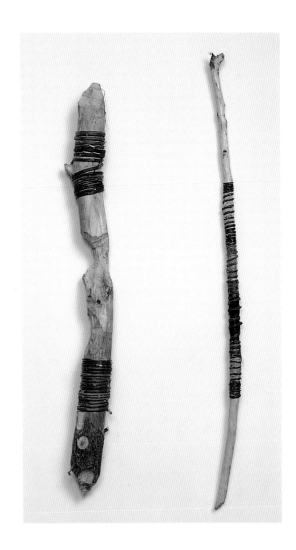

His large-scale works are frequently spherical, dome-shaped, conical, the shapes often readable as shelters or baskets, or as vessels or containers. His smaller bundle works, by contrast, are made from easily transportable stones, sticks or other small objects collected during a walk or journey; bound or marked, these denote the passing of time and movement from place to place, while the larger, rounded works denote spatial relationship. What gives Drury's work much of its resonance is this intrinsic tension and balancing between apparent yet complementary opposites: the open and the contained, the hidden and the revealed, yin and yang. The recent work, Covered Tumulus, for example, made on top of Firle Down in Sussex, is a dome woven over the remains of a tumulus (a prehistoric burial mound). The site of the dome is such that it can be seen for miles, as could the original mound. In the act of covering it, Drury is, paradoxically, revealing the mound. The physical labour involved in single-handedly constructing this huge dome (almost ten metres in diameter) in one day from dawn to dusk constitutes the yang element; what is constructed (a symbolic container) and the focused attention in the construction constitute the yin element. Equally significant in this particular work is that it acts as a reminder of the presence of time, and of the peoples before us who deemed that particular site fitting for the burial of their dead.

Recently, Drury has begun to weave together maps of places he has visited: West Cork and Bandolier, New Mexico, for example, are now irrevocably linked through the weaving together of maps according to a spiral design found in the ancient cultures of both places. In so doing, he is moving, and inviting us to move, across time and space simultaneously.

It is not unusual for Drury to find, after completing a work, that something similar has been made, or has occurred naturally, in or near that place before. Perhaps this is not surprising, given that what he makes arises out of a largely intuitive process. In Drury's words, it is 'nature itself that communicates'. In a recent project in Japan, for example, after days of trying to build a construction of tall cones that he had conceptualised in England beforehand, he found himself making a series of spheres. The place, he says, refused to let him make the original construction and insisted that he make the spheres. He was subsequently shown a large natural stone sphere in a nearby village, a stone which had been given sacred status. The place in which he made the spheres was a narrow ledge at the top of a gorge, within which was a waterfall. Theodor Schwenk, in his book on forms in water and air, points out that water tends always to take on a spherical form: 'Falling as a drop, water oscillates about the form of a sphere . . . A sphere is a totality, a whole, and water will always attempt to form an organic whole by joining what is divided and uniting it in circulation.'*

BEAVER STICKS

sticks from a beaver dam in Sierra Madre, California, bound with willow, sage, bark, reed and yucca

1991

*Theodor Schwenk, *Sensitive Chaos: The Creation of Flowing Forms in Water and Air*, Schocken Books, New York, 1978, p.13

*Reason in 'The World's Room...'.

Drury's sensitivity to the 'particularities of place', and the sense in which he seems to act as conduit for its spirit, have led to his work being characterised as a kind of shamanism.* A shaman assumes power – the power of evocation, of healing and of maintaining nature's balance, of ecstatic transcendence. Drury, by contrast, goes with a genuine openness to a place, aiming not to heal it, nor consciously to capture its essence, nor to alter any part of it in a fundamental way. Indeed, he goes with as few expectations as possible. Obviously, if he is commissioned to make a piece, he has

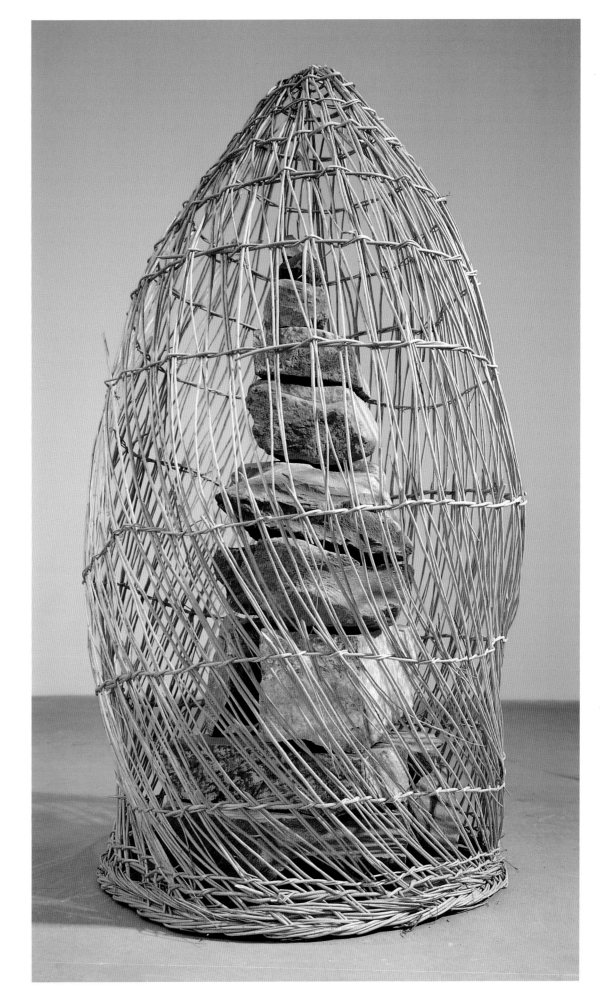

BASKET CAIRN

willow and stone

1991

TIDELINES

beach walks ripple marks phases of the moon

1985

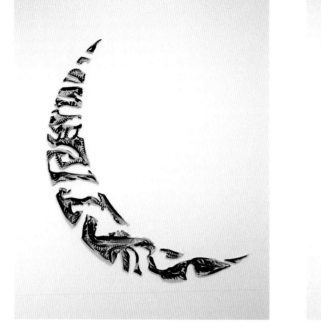

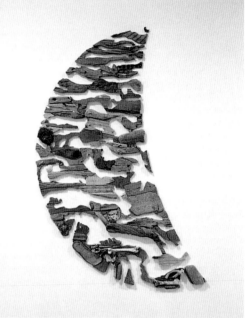

MOON

dark seabird feathers

WAVE

driftwood

to visit the site in advance, and produce plans and designs. But in the making, his position is one of alert surrender to the place itself and to his own mental and physical strengths and limitations. This may result in his work appearing to have, or indeed possessing, a shamanistic quality, but had this been his intention, any such power would have been destroyed.

The development of Drury's work, from Medicine Wheel to the very recent mushroom prints and woven maps, embodies his view of the world as a 'woven web of interconnections'. In the process of making works, he has found common cultural ground all over the world. In Japan, for example, when working with craftspeople, artists, friends, a priest, children, it became clear to him that nationality was insignificant:

'The most useful thing to come out of such collaborative projects is that, if only temporarily, nationality breaks down. It isn't a clashing of cultures, or even a merging of cultures, but culture seems to disappear, so that what is left behind are the memories, often more lasting than the thing itself.'

Human energy and memories know neither national nor cultural borders. The impermanence of the structure or object serves to enhance the spiritual dimension of the collaborative work, and, moreover, allows space and labour to defy cultural history. In his book, *Landscape and Memory*, Simon Schama observes that 'National identity . . . would lose much of its ferocious enchantment without the mystique of a particular landscape tradition: its topography mapped, elaborated and enriched as a homeland.'* Drury's work seems to have the power to cut through such cultural tradition, with the effect not of asserting an a-historical 'nature', but of illuminating the relationship between culture and the physical world.

Drury has often worked with both children and adults, in residencies at schools and colleges. Such ventures usually involve groups going into woods or fields and constructing, first, a shelter of some kind, as protection from the weather and for sleeping, cooking and eating in. In projects with young schoolchildren this has sometimes been the children's first real encounter with natural

*Simon Schama, *Landscape and Memory*, HarperCollins, London, and Knopf, New York, 1995.

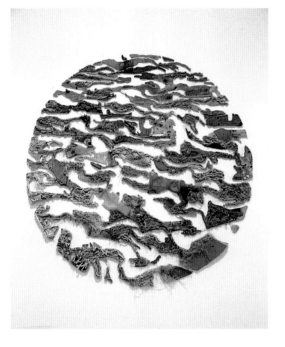

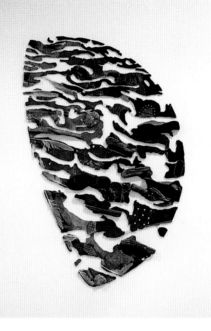

BREATH

blue and green plastic

CLOUD

metal, rubber, industrial waste

WIND

white gull feathers

*David Wood in the report on Chris Drury's residency at Cranbrook Primary and Secondary Schools, October 1991, South East Arts/Kent County Council.

materials and with the elements. Having to build their own structures from materials whose strength and pliability they must test, learning how to weave, plait, thatch, bind, having to work together, discovering that once a shelter is built they can try out being different types of people . . . all these things have given many children (and adults) a chance to reconsider their relationship to the land around them. As the Head Teacher of a primary school put it, after a three-week project: 'Something was unlocked in those three weeks. Unlocked in children and teachers. A confidence perhaps.'* Whilst we are separated from the actuality of land, water, air and plants – by our intellects as well as by industrial and technological developments – we do indeed lack the confidence that develops from this crucial source of understanding.

There is, in fact, a quality or sensibility in Drury's work which moves us to reconsider, in the poet Elizabeth Bishop's words, 'what we imagine knowledge to be' - something that is, she says,

> dark, salt, clear, moving, utterly free,
> drawn from the cold hard mouth
> of the world, derived from the rocky breasts
> forever, flowing and drawn, and since
> our knowledge is historical, flowing, and flown.

from 'At the Fishhouses' (1955)

Chris Drury's art is a story of rhythms, tensions and conflicts, labour, ritual and human intelligence. Each piece of work is a complete narrative, opening out gradually and reaching (temporary) resolution. Every decision about which material to use, which shape to create, where to place a work, whether or how to photograph or record it, and how to think about the contradictions between the work and its reproduction (whether in the gallery or in this book) is a dramatic act that defines, dissolves and renews perceptions about the relationship between nature and culture.

MEDICINE WHEEL

Walking in the stubble fields
looking down
waiting for the first lapwing feathers of the year
two feathers lie together

16th August 1982

As I bent down to pick up those two lapwing feathers, I realised instantly that I should make a work by doing just that: picking something up off the earth every day for a year to make an object calendar. By the time I had returned home from walking the dog, I had worked out how to do it. The two feathers formed the first object day of this eight-foot wheel. As it was August and harvest time, I collected straw for the pulp of the first segment of paper. These segments were made each month and pressed on to a circular plaster mould of a section through a tree trunk, its annual rings marking a century-old cycle of growth (*see* illustration on page 83). The structure was made up of twenty-four spokes of bamboo radiating from a central circle, each pair of sticks drilled to carry fifteen or sixteen objects. And so I consciously entered into the unique and intimate time-scale of a turning year.

At first this appeared to be an utterly daunting and life-restricting task: to choose an object without fail every day for a year. The trouble is that if you set out at, say, 3 pm each day to find a natural object, you are confronted with multiple choice, and this is confusion. I rapidly let go of choice altogether, learning to allow objects to come to me. In the end, I always had more than enough for each day. These objects would sit on a tray waiting to be strung into place at the end of the week, their selection determined by appropriateness and fit for the spacing between spokes. Sometimes I would invite a friend to choose a day and find an object. My family became involved; some of the most compelling things were found by my children.

The wheel follows the seasons, and I was inevitably drawn into this cycle, but it also marks my inner year, reflecting its joys and tragedies (my father died during this year).

Contained within this one work are the seeds of everything I have done since. I called it Medicine Wheel out of the blue, and then discovered that a medicine wheel was used in a Native American form of cosmology, giving a cultural meaning to the outer world. This, in itself, started me on a journey of making shelters and baskets as a way of linking cultural objects to the outer world of landscape and place and time. The finding of objects led me to link material and object to a found moment in time and space, and to a fascination with plants and their properties, including mushrooms, which are represented at the centre of the wheel. The very basis of all my work – the movement between outside and inside – is the Medicine Wheel's hidden but vital component.

MEDICINE WHEEL

One natural object for each day of the year

twelve segments of paper, one for each month, made during that month from the pulp of particular plants

a mushroom print

16th August 1982 – 15th August 1983

THE DAYS

16th-31st August 1982
lapwing primary feathers
plum stones
broom seeds
ash seeds
orange peel
gorse
rowan berries
hop twig
wood pigeon tail feather
yew bark
rabbit bones
beach pebbles
dryad's saddle fungus
cat's skull
collared dove feather
butterfly in blackthorn resin

September
cob nuts
beech nuts
beech nut husks
acorns
sycamore seeds
Scots pine cones
Cyprus pine cones
haws
corn dolly
hips
pumpkin seeds
beach pebbles
field maple seeds
larch twig
acorns
melon seeds
horsetail
gull feather
conkers
conker husks
haws
maple seeds
French beans
plane seeds
runner beans
shells
snail shell and honeycomb
conkers
gourd
gourd seeds

October
acorns in fungus
chestnut shells
acorns
chestnuts
fragment of wood
acorn cups
tree of heaven seeds
ash seeds
hogweed stem
objects from Chanctonbury Ring
hedgehog quills
honesty
seaweed
porcupine quill
lime tree seeds
nasturtium seeds
dock stalk

almonds
nettle stalk
seabelt stalk
yarrow stalk
sheep's rib
holm oak acorns
shells
chestnuts
cuttlefish
hazel catkins
many-zoned polypore fungus
wheat seeds
many-zoned polypore fungus
unidentified berries

November
bark with lichen
spindle berries
lamb bones
green woodcup fungus
wood with lichen
dogwood berries
sloes
poppy seedheads
tree fungus
rosehips
unidentified feathers
dead man's fingers fungus
bootlace fungus
runner beans
bracken stem
spindle berries
privet berries
rabbit skin
dogwood berries
seabelt roots
sheep bone
dog rose
figs
snail shells
laburnum seeds
bone fragment
Monterey pine cone
Monterey pine flowers
horse chestnut growth
sea-sponge

December
avocado stones
avocado skin
oak apples
crab shell
unidentified black berries
wild arum berries
ivy berries
everlasting flowers
burdock
Chinese lanterns
mussels
crab apples
wood with fungus
duck down
ivy branch
unidentified red berries
elm wood
Christmas tree branch
mistletoe
holly

goose feather
holly berries
walnuts
mixed nuts
alder branch
satsuma
bracket fungus
quince
ivy wood
pebble
cork

January
hornbeam twig
dogwood twig
thistle stalk
ash twig
teasel
thorn growth
twig with wool
scallop
burnt Christmas tree twig
sweet chestnut bark
unidentified red berries
teal feathers
plane tree twig
yellow twig
corkscrew hazel
pheasant down
milkvetch stem
milkvetch seed heads
hazel catkins
iris seed heads
bell seed heads
seaweed stipe
buddleia seeds
chicken down
sweet chestnut twig
rabbit droppings
runner bean
chewed apple twig
crab's claw
lamb's skull
coconut fragment

February
hawthorn twig
stripped hawthorn twig
honeysuckle twig
hen feather
oak twig
hornbeam twig
broom twig
dead elder twig
hen feather
sheep bone
turkey feather
oak apples on oak twig
shells and chalk
driftwood root
goose feather
peeled spruce
gull feather
skull fragments
dock stalk
scallops and pebble
bone
rabbit fur

rabbit bones
wool
sheep backbones
hawthorn
bone fragment
crab

18 DAYS OF SNOW ON THE GROUND

March
ivy berries
apple
pebble
sheep's backbone
cramp ball fungus
burnt root
musk mallow
pussy willow
hazel catkins
guinea-fowl feather
Hindu prayer paint on elm
horsetail
horsetail
thistle
beech twig
chestnut twig
pussy willow
seaweed stem
sycamore twig
sparrow wings
guinea-fowl feathers
lime twig
sheep droppings
hen feather
mole skin
elder twig
fox skull
squirrel husks
beech twig
wood pigeon tail feather
tulip tree seeds

April
fir cone - Greenham Common
shells
egg painted by child
pebbles
delphinium seed heads
willow twig
chestnut twig
fish bones
seed heads - Findhorn
pine needles, pine flowers,
feather - Findhorn
giant hogweed - River Findhorn
fulmar feather - River Findhorn
moss and heather - Ben Alder
deer scats - Ben Alder
Scots pine - Ben Alder
deer-related objects - Ben Alder
bamboo with bluebell
crab's claw
aspen catkins
chicken feathers
larch twig
pussy willow
lychees

crow feather
hornbeam twig
beech twig
ash flower
birch bark
skeletal holly leaf
grapefruit

May
may twig
goat willow
pussy willow
cuckoo feather
crow down and egg shell
oak twig
dove down
fish bone with minnow and shell
spruce flowers
spruce bark with primrose
hornbeam and clematis
crab apples
larch twig
beetle markings on pine
lamb's tail
rhododendron twig
bracken and buttercup on bark
magpie feather
cherry bark with butterfly, moth and apple blossom
jay feather
poplar bark with cherry blossom
fern on dead wood
moth on rotten wood
horsetail
blackbird eggs
pheasant feather
pheasant feather
Scots pine flower
moths on burnt wood
blue flint
pheasant egg

June
crow feather
bark with flower
crow feather
crow feather
crow feather
tortoiseshell on bark
crow feather
wood pigeon feather
crow feather
moth on dead twig
crow feather
burnt wood
crow feather
crow feather
pheasant feather
cherry stones
sedge
wild oats
bluebell seed pods
speckled wood butterfly on walnut bark
lark feathers
Timothy grass
feral pigeon feathers

lapwing secondaries
soft brome grass
fieldmouse skin
magpie feather
moorhen feather
bindweed on bark
pomegranate

July
pomegranate
crow garlic
swan's egg
carrot
crab
foxtail
meadow grass
pheasant feather
columbine on oak bark
wild barley
soft rush
shepherd's purse
Jack-by-the-Hedge
swallow tail
swallow wing
lapwing tail feathers
rye grass
peacock butterfly on a parsnip stem
barley
wheat
Yorkshire fog
peach stones
tor grass
crested dog's tail
yellow rattle
cow pat
shells
snail shells
wall barley
three pebbles
tiger moth on a thistle

HIGH SUMMER SUN

August
little owl feather
little owl feather
magnolia petals
wild carrot
crow garlic
magnolia fruit
poppy seed heads
seed heads from Eastport Lane
columbine seed heads
delphinium seed heads
roasted peanuts
sea cabbage seeds
knapweed
Aaron's Rod
reedmace

16th August 1983
many lapwing feathers on the low lying fields

See page 82 for details of plant pulp centre of Medicine Wheel

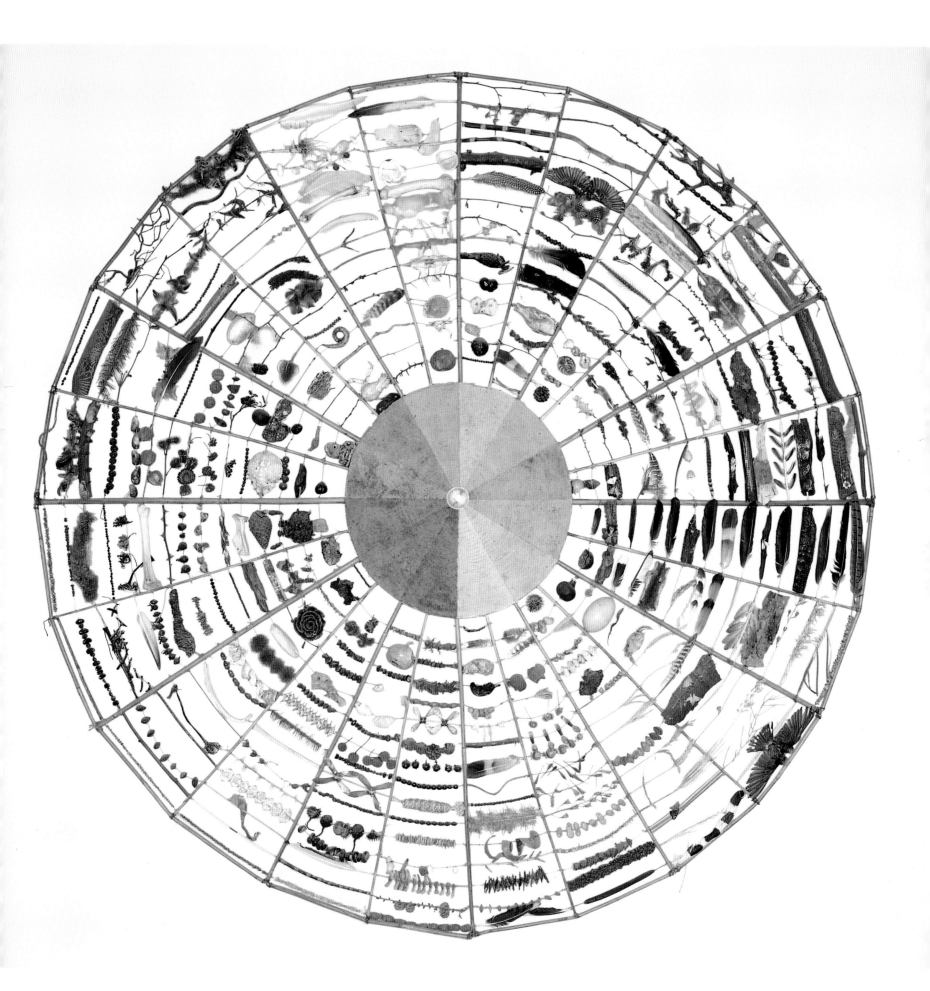

SHELTERS AND BASKETS

In October 1974 I went with Hamish Fulton to the Canadian Rockies. We walked in heavy snow for twelve days. We had brought with us a small red tent but no insulated mats. Each evening we made a mattress of overlapping fir branches on the snow over which we pitched the tent. Often we would cook food on an open fire in blizzard conditions, sometimes at heights of 8,000 feet. Fire and shelter and warmth and food were of major importance. Ever since this time I have continued the activity of visiting and walking in such places; whether for art or pleasure, it feeds something within me. Ten years later, in 1984, I began to make art directly in such landscapes, and my instinct was to use a universal, cultural landmark – the shelter.

Shelter is a basic human need and a manifestation of human presence. It is a dwelling place within the movement of a walk. It can be made simply and quickly with materials to hand, using minimal tools. Material and site are inseparable if the shelter is to sit comfortably. If you have to walk twenty yards to pick up a stone, that is too far: the shelter is in the wrong place.

I like the way that a shelter has an interior as well as an exterior. They feel different but are connected. I like the way this interior space draws you inside yourself, enclosing, protecting, just as mountains pull you outside yourself, pushing mind and body beyond their usual confines.

Some shelters have been made in a particular place because it was time to stop walking and pitch camp for the night. There are other places – often near where I live – where I go specifically to stay and make a work. Such areas may be tucked just round the corner from houses or villages; building here requires quietness and stealth. To those who discover the structures, they are like mushrooms that have sprung up overnight; in time they will rot back into the earth.

Sometimes shelters are commissioned, such as the 'Wilderness Sanctuary', made in Ireland with the artist, Alfio Bonanno. Here the brief was that it should be big enough to hold a bed and chair, weatherproof, and made from locally available materials in a place where somebody can stay, even in winter, and be a part of the extraordinary landscape. This shelter is perched on the side of a mountain, and is made from stone, logs and turf. It is virtually invisible from 100 yards away, has views to the sea and Bull Rock, and yet it is only twenty minutes' walk to the pub. The intention was to provide a space for being and contemplation.

There are shelters built inside as installations in galleries. Here they dominate a space, becoming less about shelter and more about mysterious, enclosed space – womblike, fecund. Some shelters are like overturned boats and denote journey, movement. Others I have brought inside and reversed so that, for example, the outside thatch becomes an inner core. This exchange between inside and outside reaches a kind of resolution in the later cloud chamber and *camera obscura* works.

Baskets complete the circle. Shelters can be made like baskets, baskets like shelters. Making woven vessels is one of our oldest crafts and is buried deep within our culture ('stripping the willow', 'don't put all your eggs in one basket'); some of the earliest boats were constructed using the techniques of basket-making. Among the baskets I make are some that are shallow and open – the woven design and whatever the basket contains are clearly visible; in other, closed baskets, the weave and design create a dark space resonant with possibility. Open baskets may contain objects that link place, material and shelter. The materials for these are easily packed into a rucksack and light enough to be carried home along with the necessities for survival in out-of-the-way places. They are made simply with minimal artifice. In gallery installations (and publications), a dialogue is set up, through photodocumentation, between shelter and basket.

STONE LAVO

Mageröya Island, North Norway, 1988

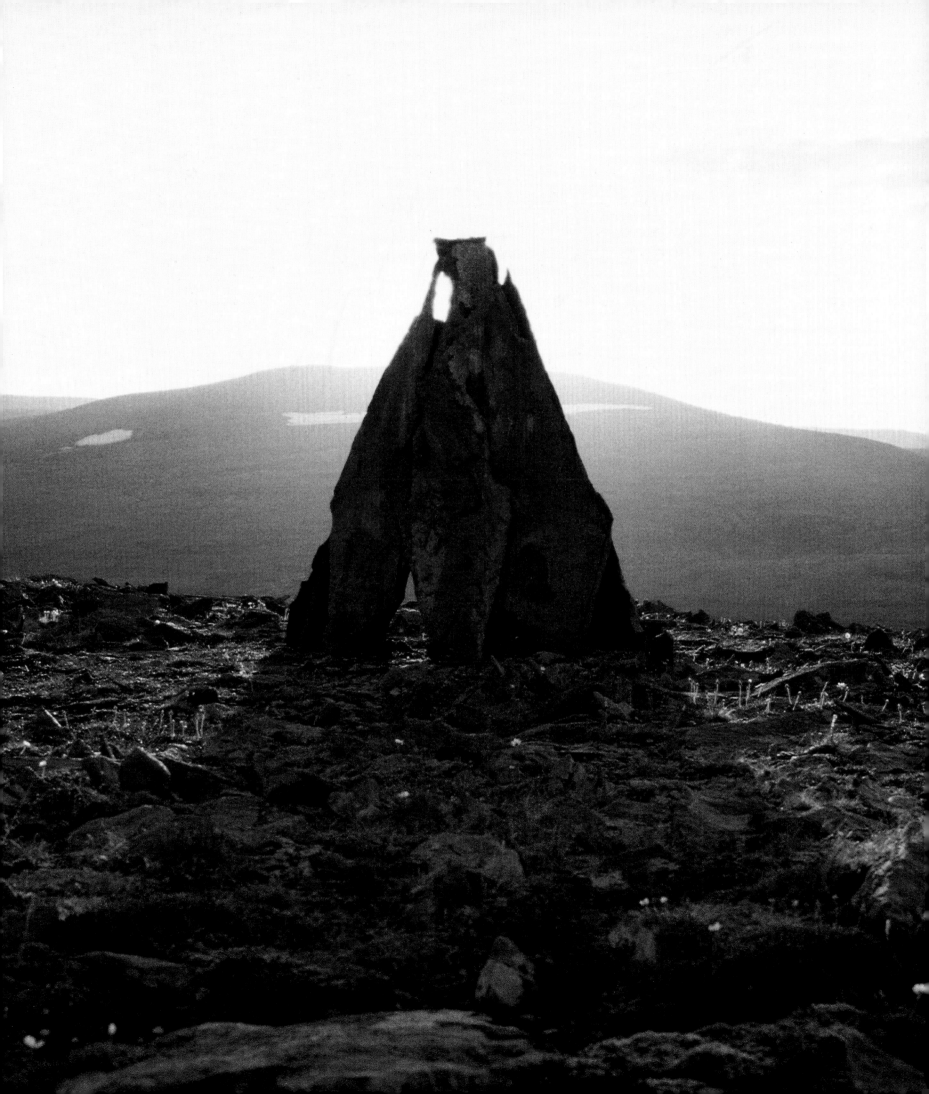

Other baskets, however, can act on their own, directly referencing the outside without recourse to photographs: for example, Medicine Basket and Basket for the Crows. A basket may also point to inner nature, to the realm of the senses, dreams and ideas. Dream Basket was prompted by a memorable, exceptionally vivid dream which, over four years, remained in my mind, so that at last I felt compelled to make it concrete in some way. (Later, I discovered by chance that it had been an 'archaic' dream, in the Jungian sense of originating in the collective unconscious.) Basket for the Moment between Death and Life was made for the point in the year when winter is almost at an end, but spring has not yet arrived; the earth pauses, as though drawing breath. The horns around the basket's opening, joining one into the other, signify the cyclical nature of the year. In pieces like these, it is possible to use more meticulous craft, because material is not related to place, but chosen for its colour, or its reference to meaning and idea. The design, weave and mind-numbing repetitive nature of this painstaking work all play a part in looking inward, just as the activity of walking does outside.

Basket-making can focus the mind. Chance can take what the human mind imposes and free it back into randomness, the true order of the world. Sometimes I have applied earth, peat, clay or cow dung to woven vessels and allowed the subsequent drying and cracking to alter and change the ordered vessel.

On occasion I have taken a basket weave, enlarged it, and turned it upside down to act as shelter

CONNEMARA VESSELS

willow, reed, rope

1988

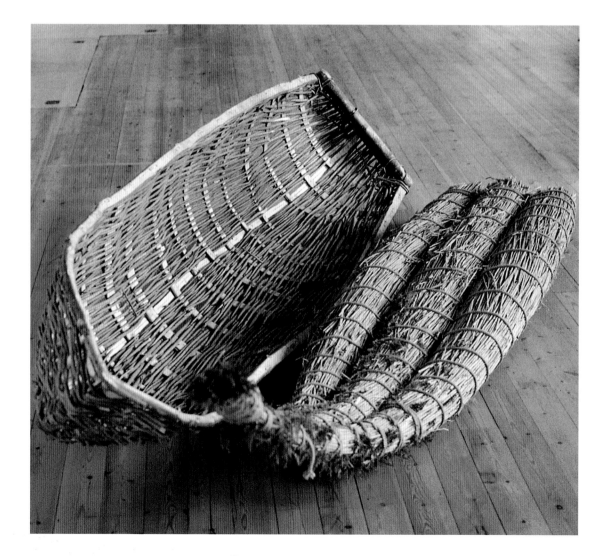

or as valve between inner and outer (as in Covered Cairn, Cuckoo Dome, and Vortex): basket to shelter, shelter to basket.

There are baskets made in series, for example, Five Sisters, which comprises three that are open, and two that are closed by being plastered with cow dung – inner/outer, closed/open. These are related to the sphere series made in Scotland in 1985 and again in Japan in 1997.

The woven map works of the last few years are an extension of basket-making. By cutting maps into strips and interweaving them, I have brought together physical and cultural similarities as well as differences in places I have visited.

Recently I have made a number of Dew Pond works. The oldest dew ponds in Sussex date from the Neolithic period. Made from layers of straw and clay, they are a water husbanding device: the warm, insulating layers of straw attract dew, while the clay prevents it from seeping away into the porous chalk of the hillside, thus providing drinking water for sheep. In the last forty years or so, farmers have increasingly resorted to a concrete surface, but once this has cracked, the dewpond is colonised by grass and can no longer function. By cutting with a spade and close treading of the muddy turf in the drying ponds, I have produced designs that echo those used in baskets that I made ten years ago. A web of interconnections links all these works.

SHELTER VESSEL

stone, willow, reed

Connemara, County Galway, Ireland, 1988

23

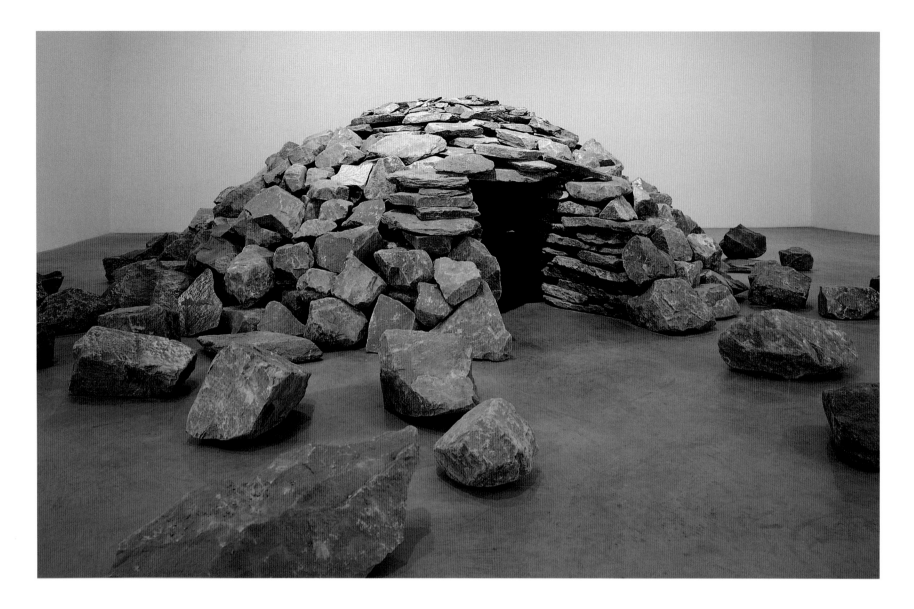

STONE CHAMBER

Los Angeles, 1991

COAL CHAMBER

willow, hazel, coal

London, 1993

CHALK CHAMBER

willow, chalk

Sussex barn, 1992

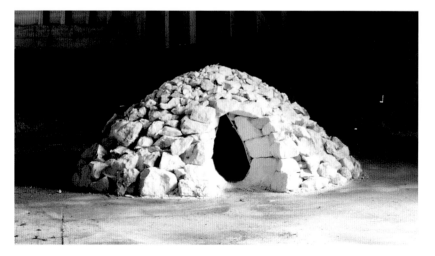

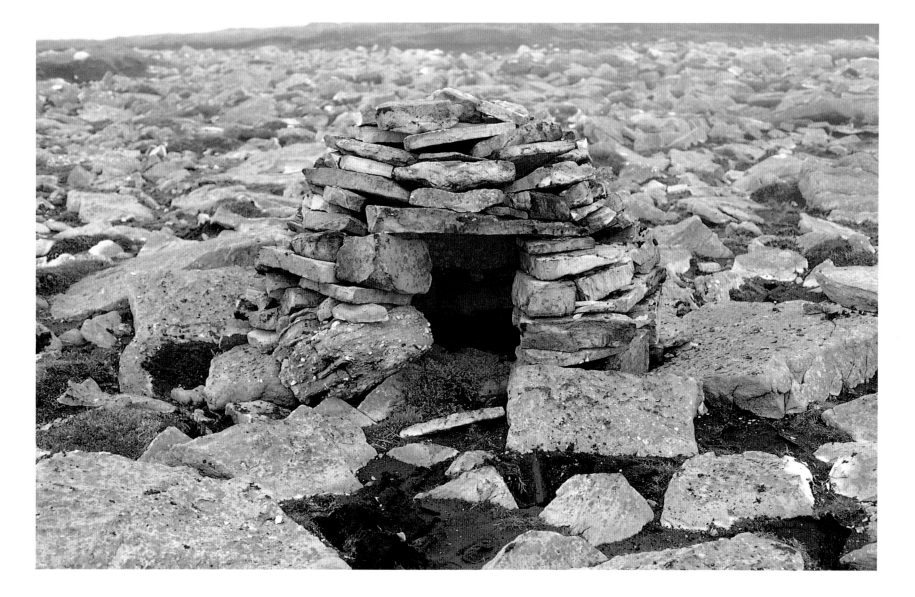

LONG VESSEL

Watergrove Reservoir, Lancashire, 1995

18-metre-long, hollow cairn made with stone from dilapidated dry-stone walls nearby. Two doorways allow entry to part of the structure and provide a pathway through for sheep.

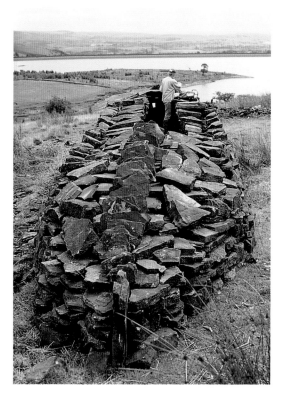

SHELTER FOR MIST

Slieve League, County Donegal, Ireland, 1985

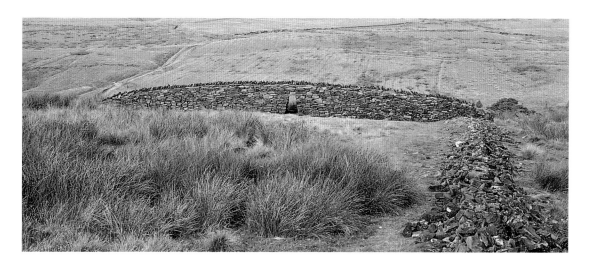

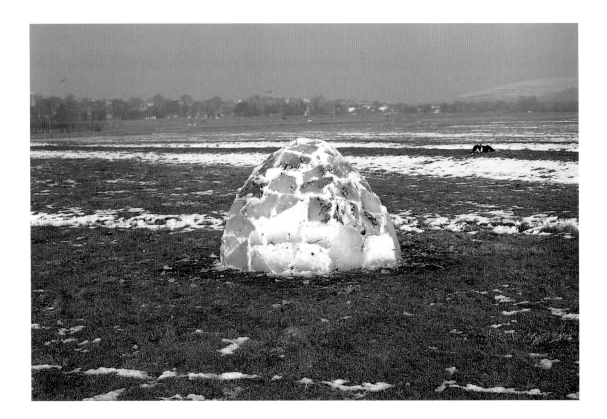

SHELTER FOR THE WINDS THAT BLOW FROM SIBERIA

ice chopped out of dyke and placed on hazel frame

Lewes, Sussex, 1986

Opposite

SHELTER FOR THE NORTHERN GLACIERS

driftwood and turf

Seiland island, North Norway, 1988

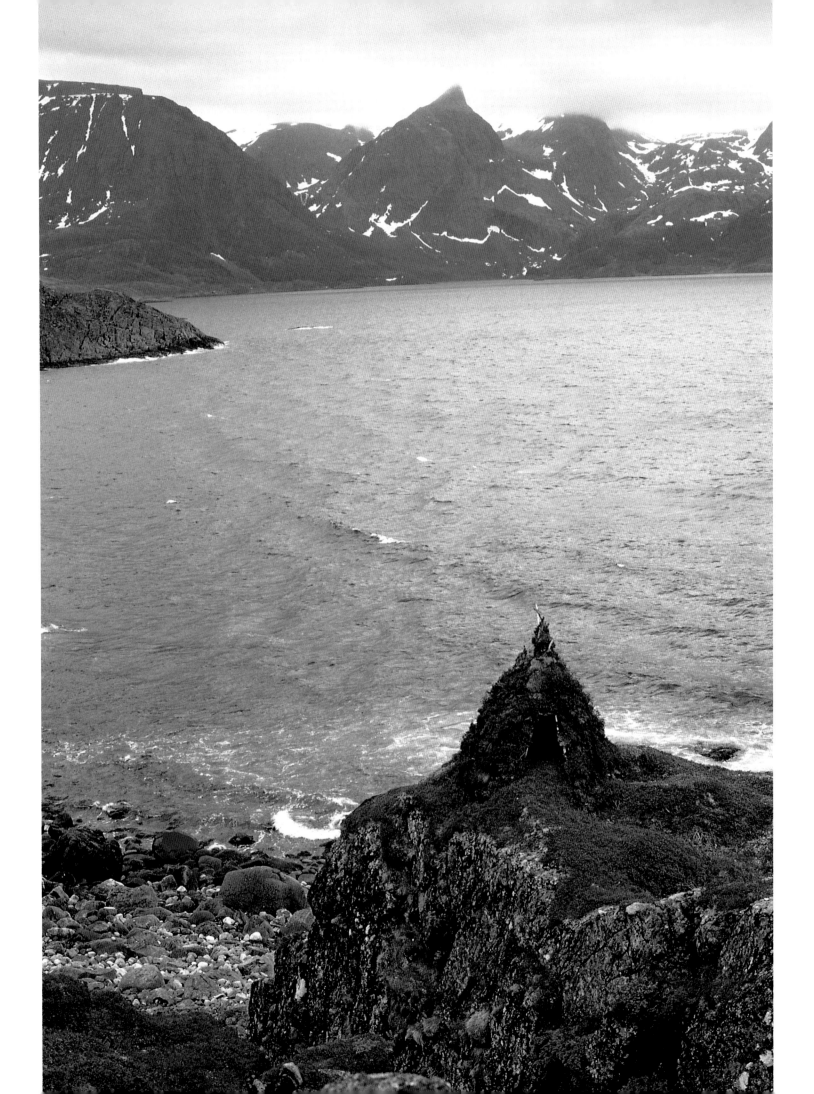

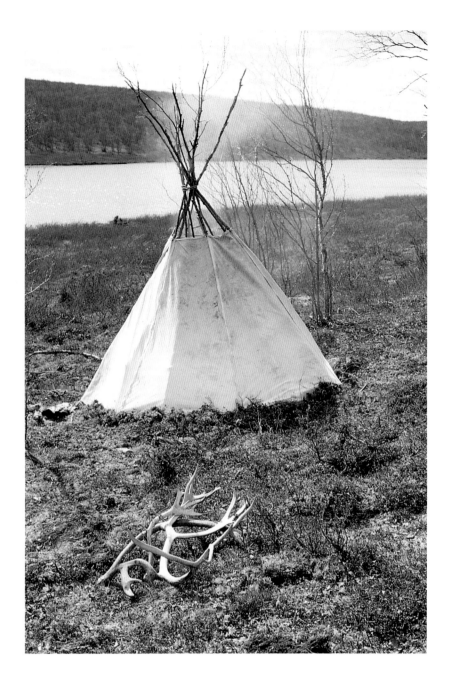

FOUR DAYS BY A LAKE

Sitting quietly, observing, watching. Small birds approach to feed on the crumbs of a meal, a lemming runs over my foot, an Arctic tern hovers above its mirror image in the lake in the midnight sun. A silver fox follows me to the tent, and we converse in short sharp barks. Over four days the tent is impregnated by soot from the fire. I collect simple objects which I attach to the canvas, and as the sun circles in the sky I mark off every hour with a star, 24 in all. The tent becomes a work, a talisman of the land.

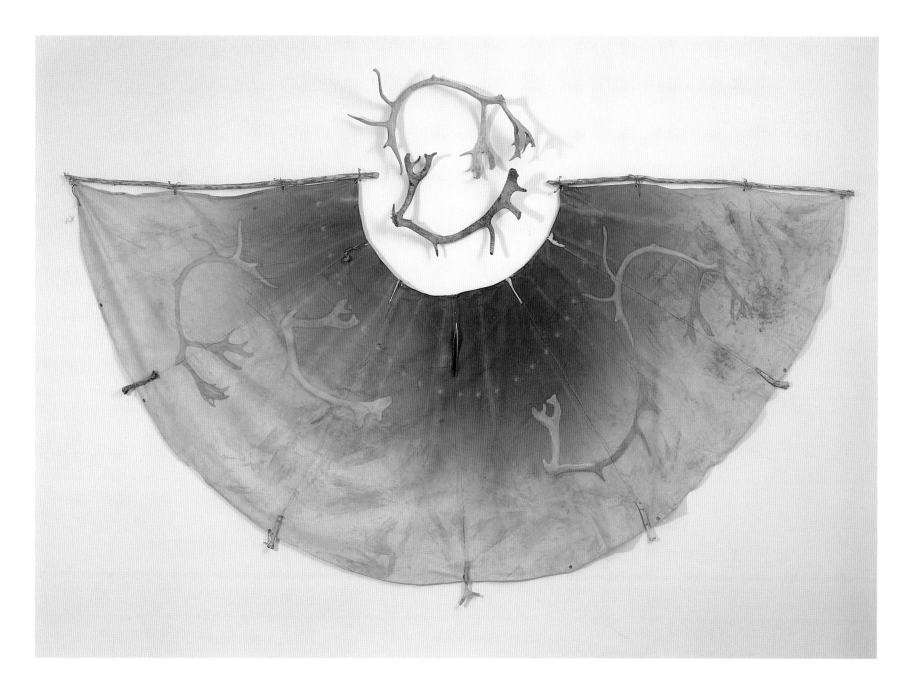

CANVAS LAVO

canvas, antlers, feathers, bones, soot, sticks

Lapland, 1988

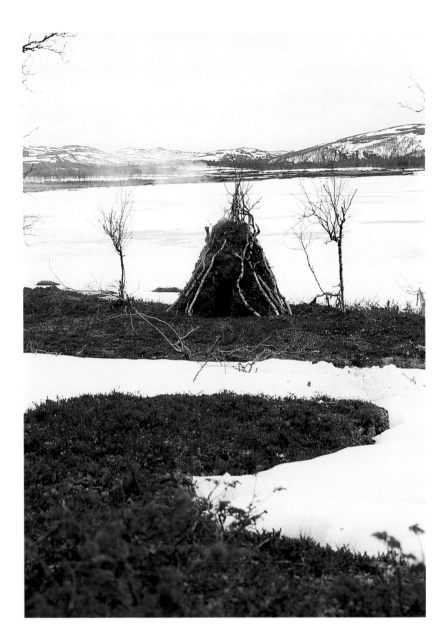

TURF LAVO

birch branches and sheets of moss
peeled off nearby rocks

Lapland, 1988

Opposite

SHADOW STUPA

charcoal and earth drawing
birch bark basket containing antler

1990

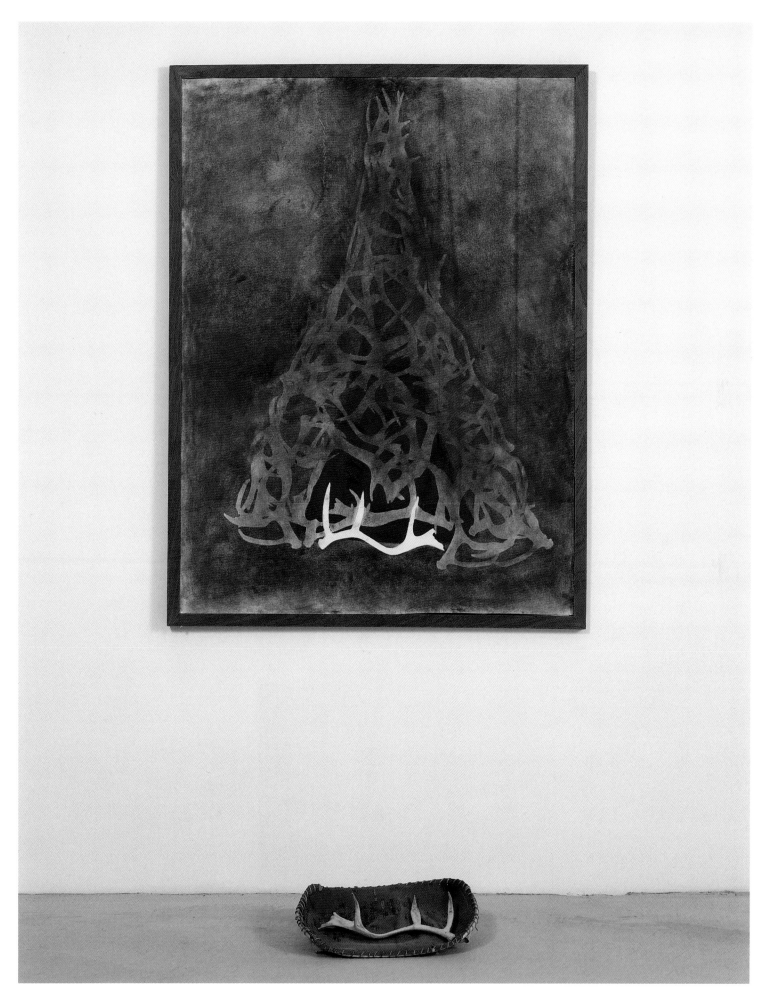

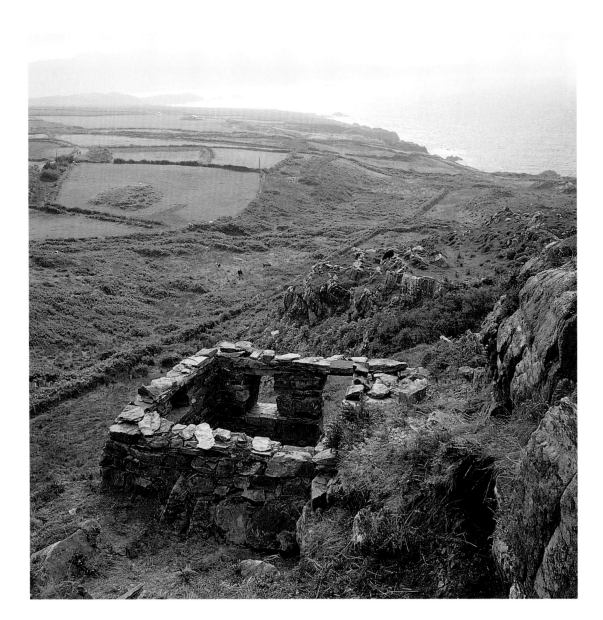

BEARA SHELTER

stone, wood, glass, turf

made in collaboration with Alfio Bonnano

Wilderness Sanctuary, Allihies, West Cork, Ireland, 1995

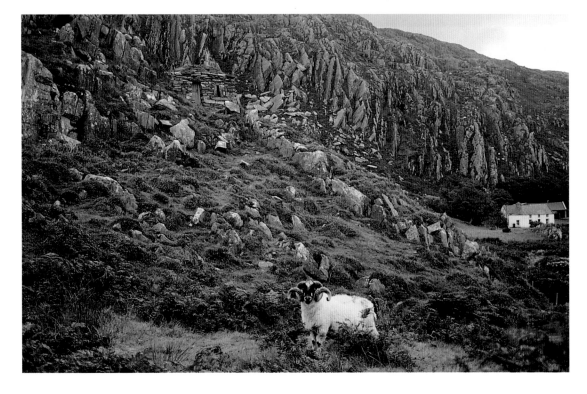

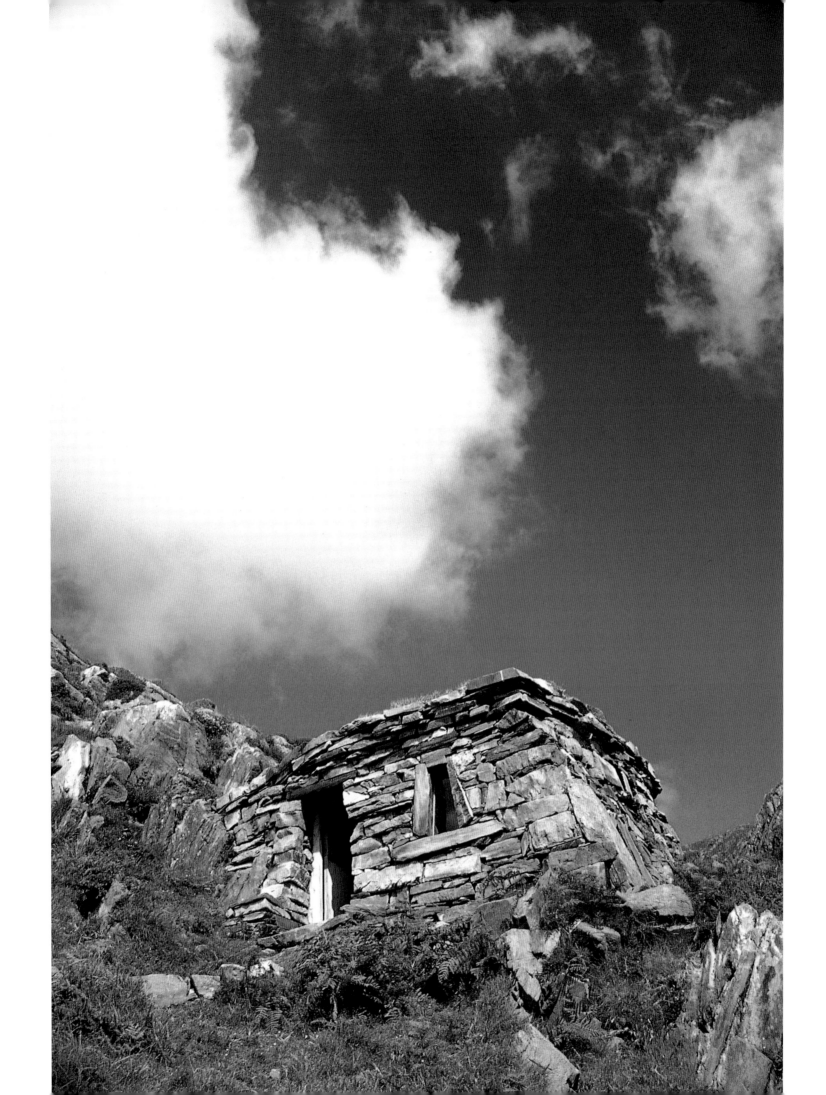

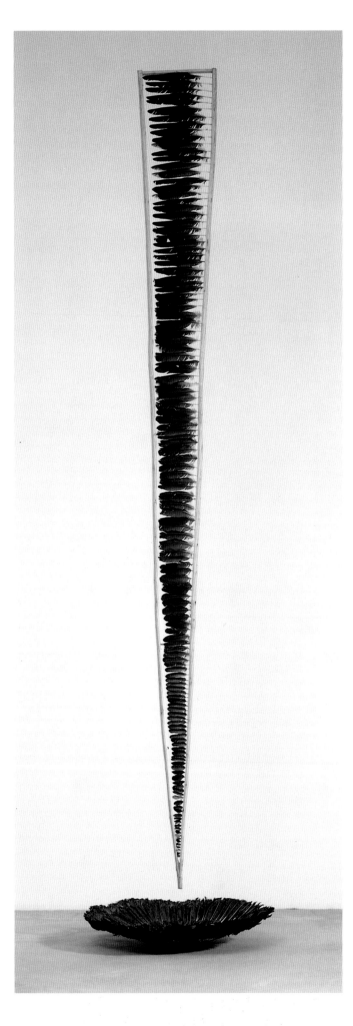

BASKET FOR THE CROWS

hazel, willow, crow feathers

1986

Born in the East (Sri Lanka).
Earliest memory, a crows' fight –
dead birds and black feathers on the streets.
In Britain crows moult in June.

On the evening of the 21st June, a friend and I pitched a tent on the slopes of A' Mhaighdean (The Maiden), in Wester Ross, and set off up the mountain to watch the sun go down. As we climbed, a cloud inversion settled into the valleys leaving all the peaks over 3,000 feet sticking up above a sea of cloud, glowing orange in the setting sun. We watched until the sun had disappeared, then headed back down through the cloud towards the refuge of the tent for the night. In the descending darkness and dense mist we lost our way, so climbed once more up the mountain. As we emerged from the cloud, a full moon rose and illuminated the whole panorama all over again. The following day, Midsummer's Day, I made first the stone shelter and then the fire cairn. The basket – birch twigs bound with pine roots and birch bark – has a sun circle in silver birch and an opening in the top in the shape of a crescent moon.

HOLLOW VESSEL

Birch twigs bound with split willow and birch bark

1989

MIDSUMMER FIRE CAIRN	SOLSTICE MOONRISE	MIDSUMMER SHELTER
Letterewe Wilderness, Wester Ross, Scotland, 1989	view from A'Mhaighdean, Wester Ross, Scotland, 1989	Letterewe Wilderness, Wester Ross, Scotland, 1989

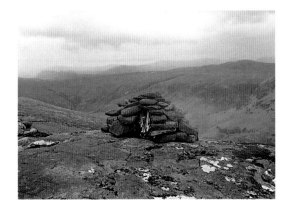

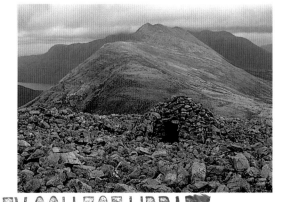

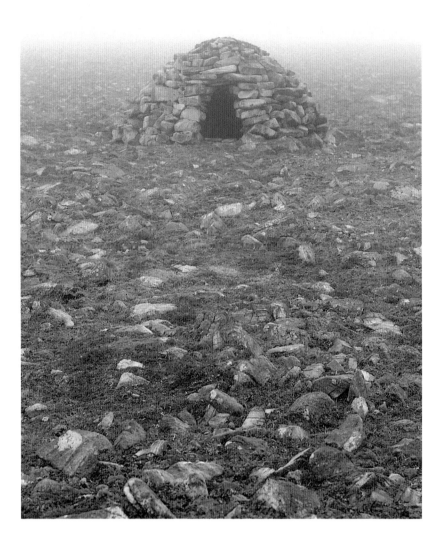

SHELTER AND BASKET
FOR THE FOUR DAYS ON MUCKISH MOUNTAIN

basket of heather, wool, stones

County Donegal, Ireland, 1986

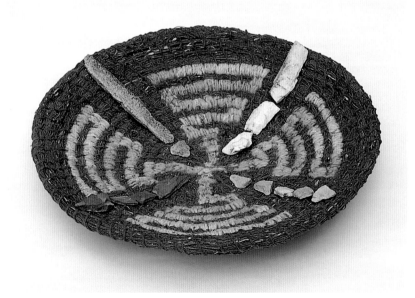

Four days on a mountain building a stone shelter and collecting heather and wool for the basket to hold the four types of rock that make up the mountain: grey and white marble, red and yellow sandstone. The design on the dewpond opposite derives from the Muckish basket pattern.

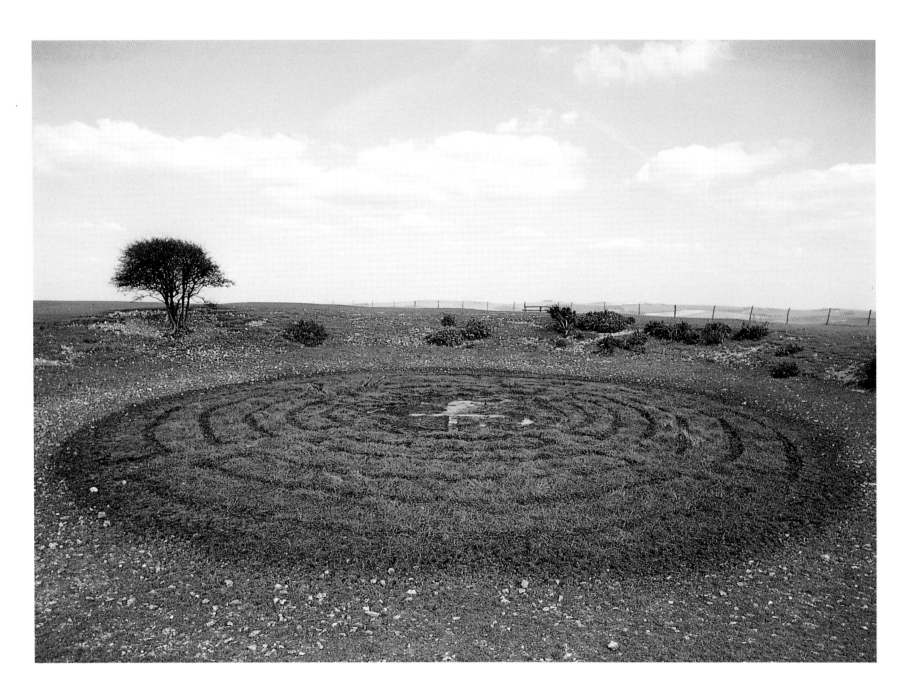

BASKET DEW POND

trodden turf

Kingston Downs, Sussex, 1997

GUARDIAN SHELTER

woven hazel and yew branches
plastered with mud

Sheffield Forest, Sussex, 1989

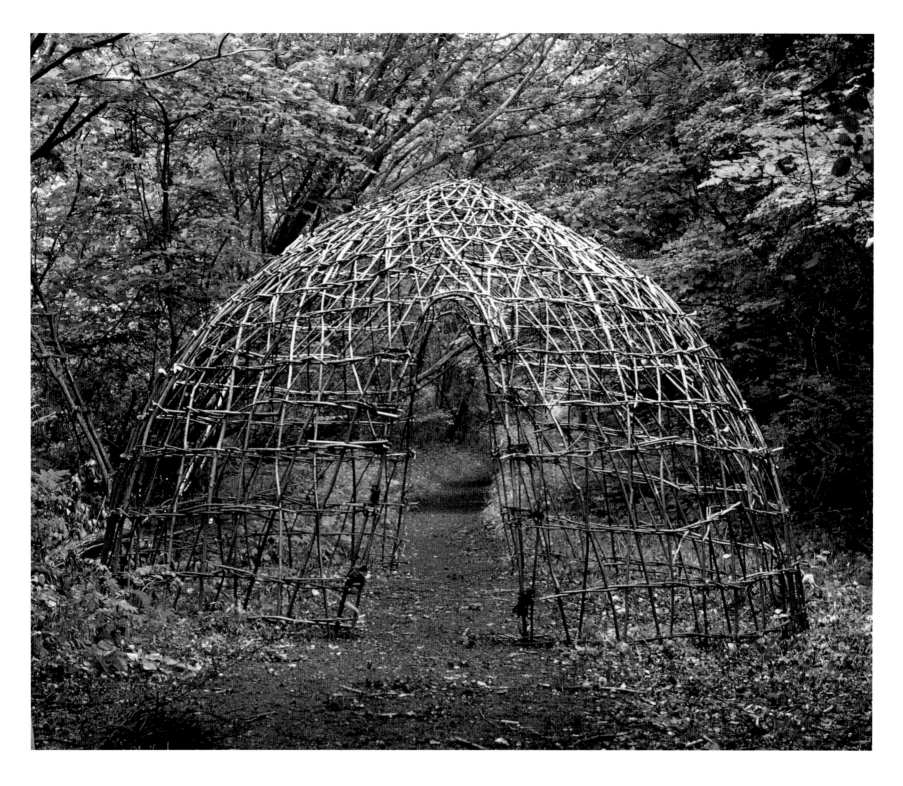

CUCKOO DOME

hazel branches

Sussex, 1992

Dome woven from hazel growing to each side of this cycle track – a work commissioned and made at the time of the global Earth Summit in Rio to point to local environmental issues. The inside is an enclosed space, but the open weave still allows in what is outside.

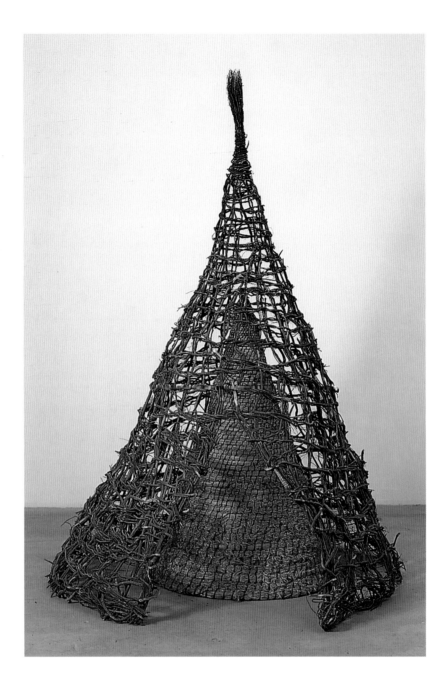

STUPA FOR THE FOREST DEER

heather branches, grass, twine

1987

Opposite, above

SHELTER FOR THE FOREST DEER

heather branches and grass

Sheffield Forest, Sussex, 1987

below

BASKET FOR THE FOREST DEER

roots and antlers

1987

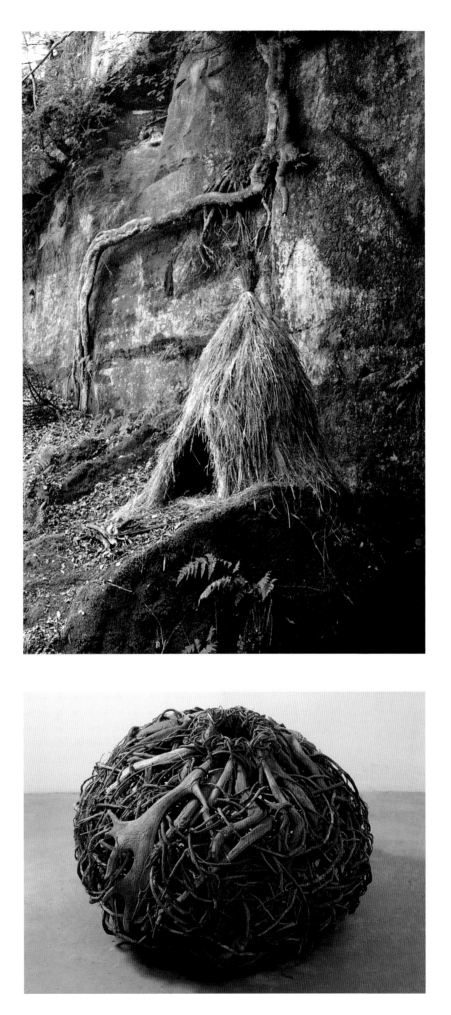

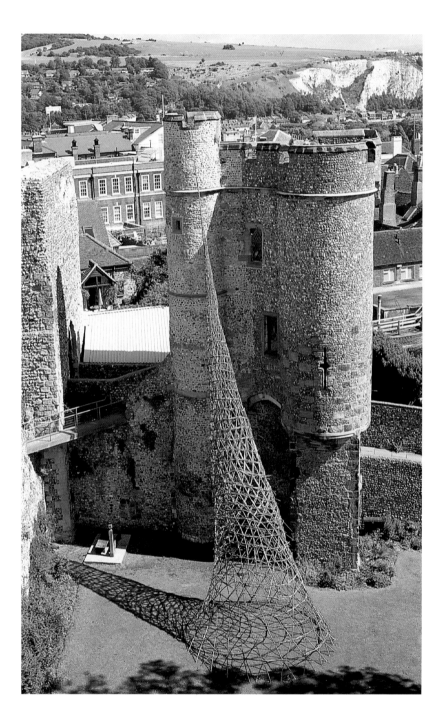

VORTEX

hazel and willow branches

Lewes Castle, Sussex, 1994

This structure of woven hazel and willow sticks (gathered from the woods and hedgerows of the surrounding countryside) was designed to interact with the space and buildings around it. The castle is solid, permanent and rooted in history. By contrast, I wanted to make a work on the same scale that was light, dynamic and impermanent. My plan was for a cone of sticks descending from the top of the barbican to the grass, reminiscent of objects falling (or being hurled) from the battlements. I used a basket-weave technique – the elements crossed and woven behind, in front, under, over – so that the whole thing was under tension. The weft was a continuous spiral from top to bottom.

I did not realise how heavy it would be, nor how difficult I would find it to weave at height, and it was touch and go whether I would succeed in joining the two sections together before the wind wrought havoc or a cable broke. I wasn't certain whether the bottom section would support the top. In theory, if the tension could be maintained throughout, it would. The working title for the sculpture was Falling Tower of Sticks. Fortunately that turned out not to be prophetic.

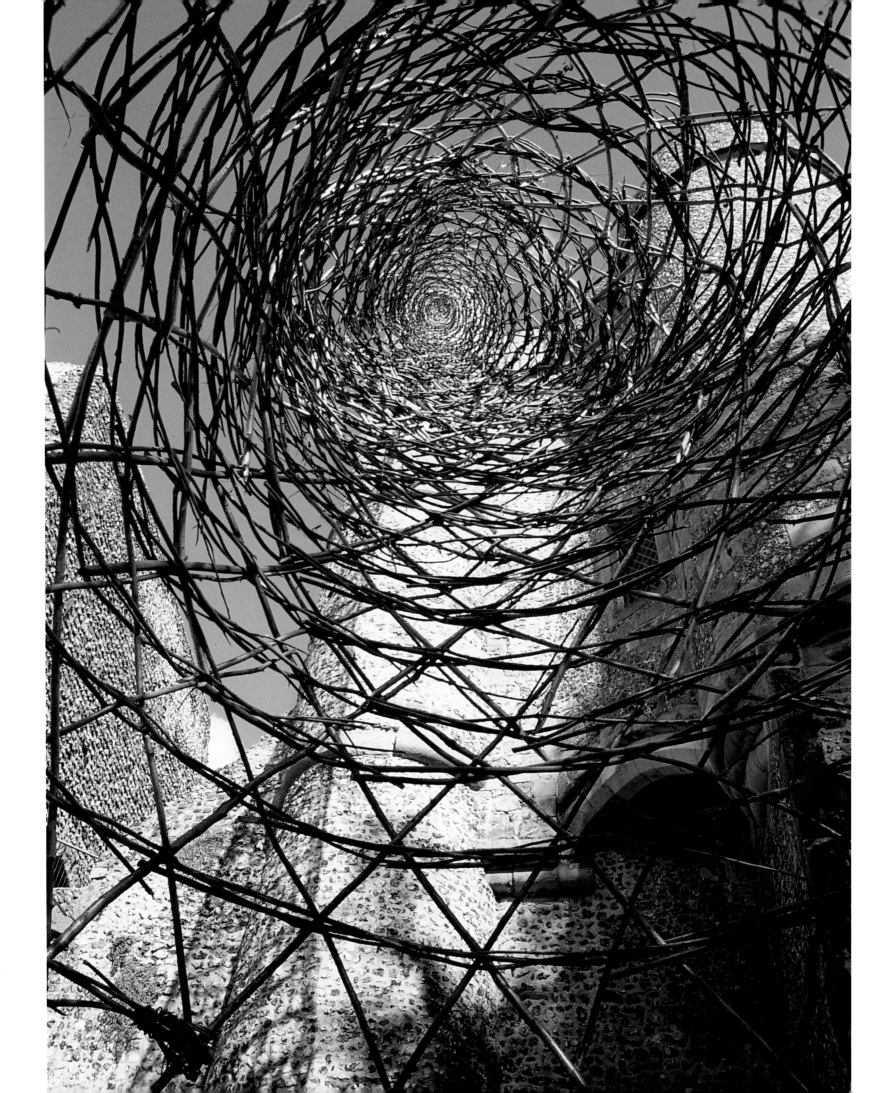

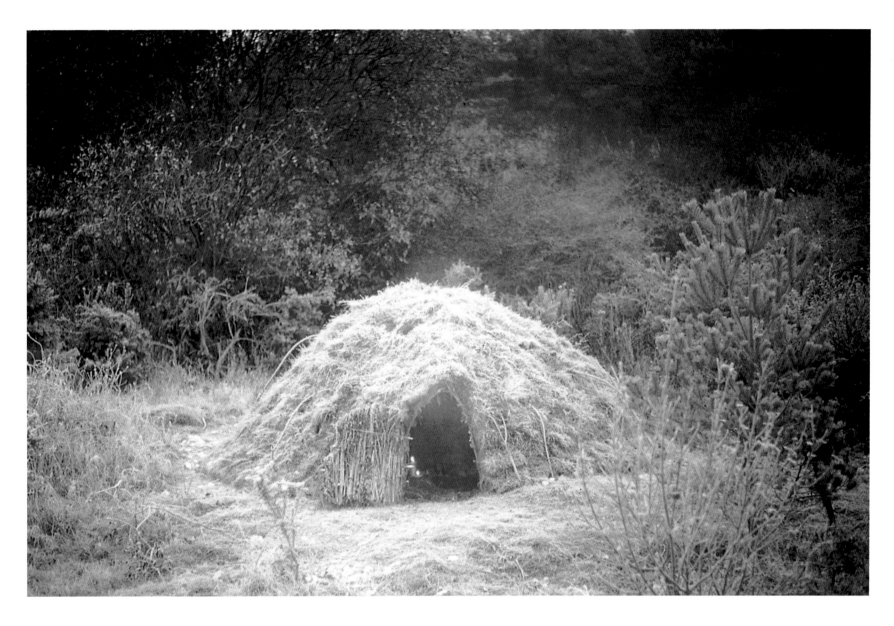

SHELTER FOR DREAMING

hazel and dogwood branches covered with turf

Friston Forest, Sussex, 1985

DREAM BASKET

willow, bramble, hazel, owl feathers

1985

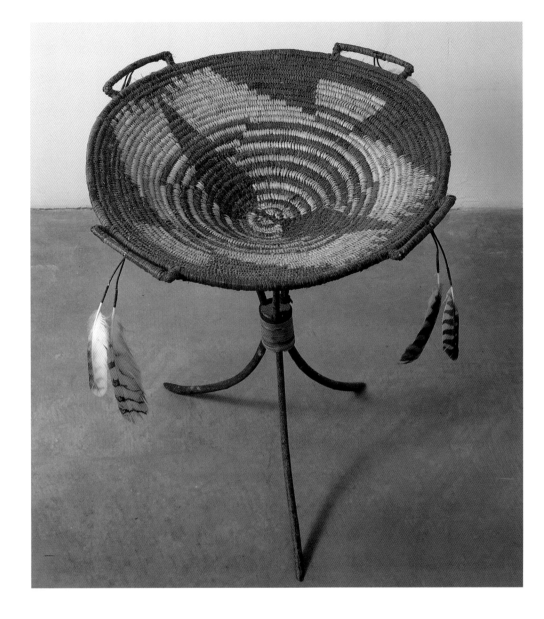

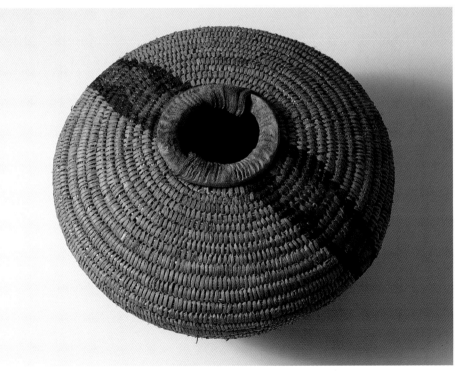

BASKET FOR THE MOMENT
BETWEEN DEATH AND LIFE

willow, ash bark, birch bark, sheep's horns

1985

WOVEN MAPS

A plant in the Arctic reminds you of a plant in the Cairngorms in Scotland: they are related but with small adaptations. So too with animals and birds and humans, even cultures: they are the same, with minor differences. This fact has always struck me forcibly, and I have begun to weave together places, islands, mountain ranges and states, all relating to areas I have visited.

Sometimes I have woven together opposites – for example, Hebrides/Manhattan. The weave is the common currency between the two. In the West Cork/New Mexico work, the maze pattern is one found in both Celtic and Pueblo cultures. Differences point to what makes our world so strikingly beautiful. Commonality makes us whole.

With the Sussex Downland works, Tumulus and Dew Pond, I took two identical maps of the same area and pigmented one with reconstituted downland grass, i.e. sheep shit. These maps were then cut into strips and woven together – the pigment producing the design, and the weave allowing for both convex and concave shapes. These works are then echoed in the dew pond interventions and in the covered tumulus, which was woven in one day, from dawn to dusk, over a burial mound east of Firle Beacon in Sussex.

HEBRIDES/MANHATTAN

(detail)

woven maps and watercolour

1996

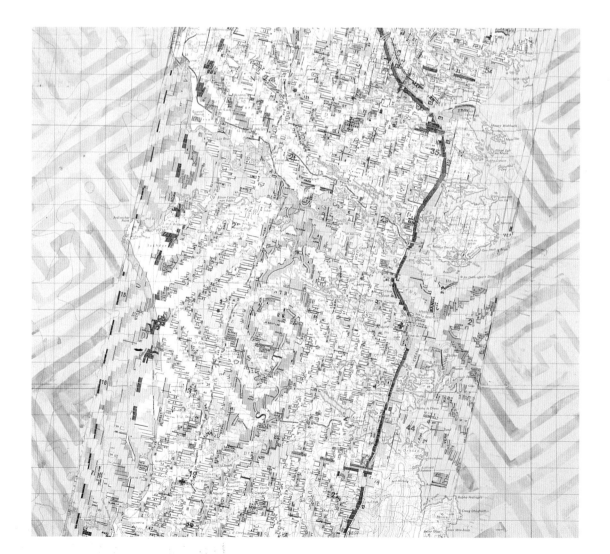

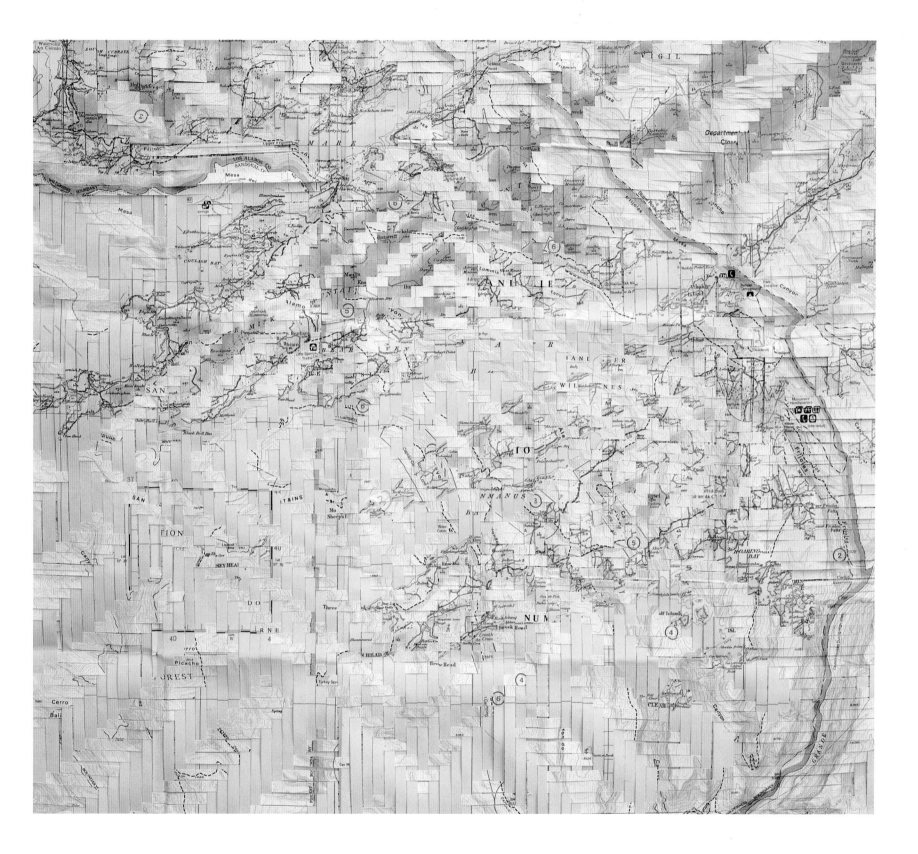

WEST CORK/NEW MEXICO

woven maps

1995

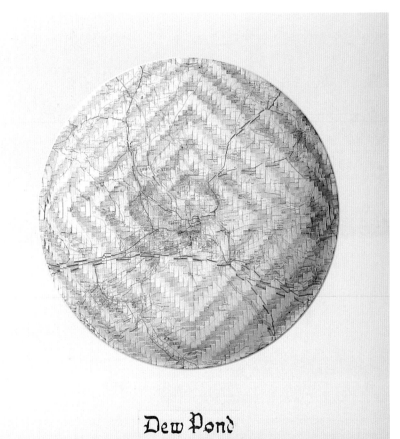

DEW POND

woven maps,
one pigmented with sheep's droppings

1995

Opposite

SPIRAL DEW POND

turf cut and moved with spade

Oxteddle Bottom, Sussex, 1997

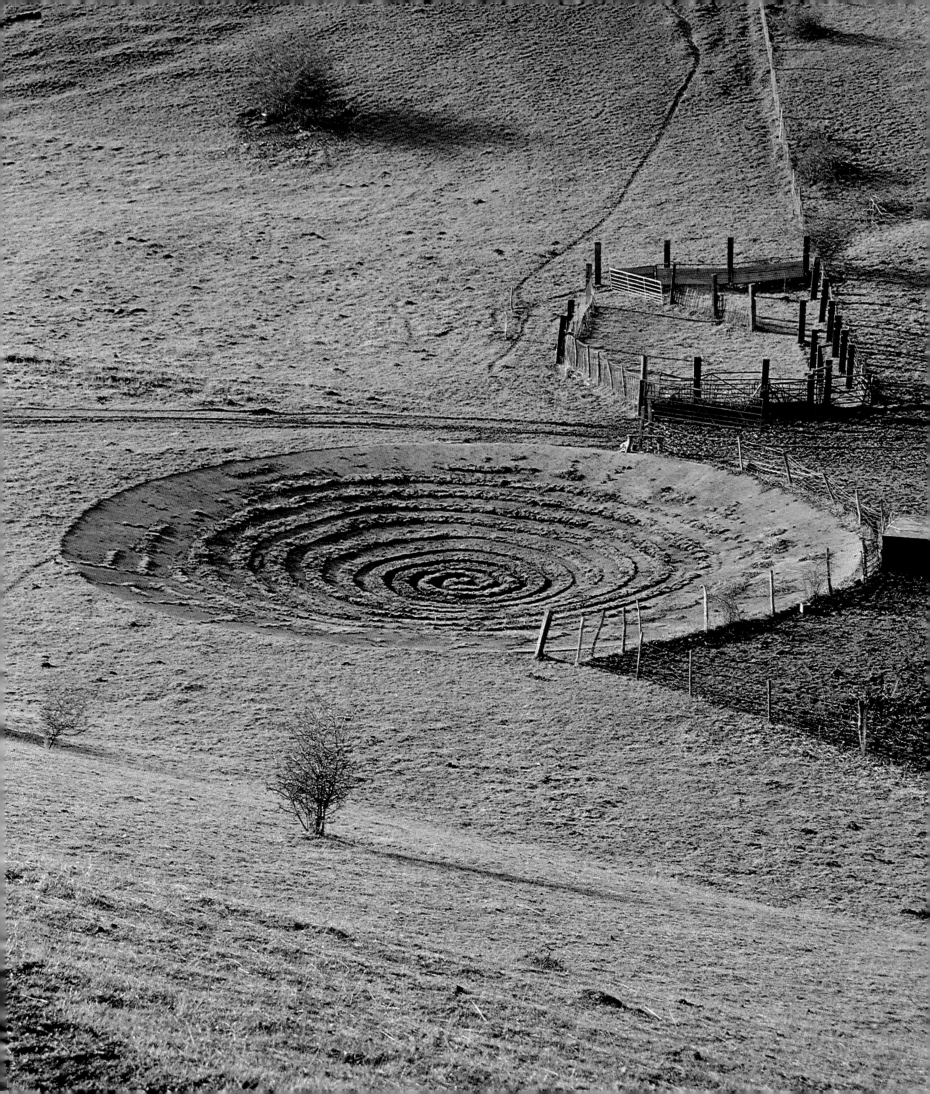

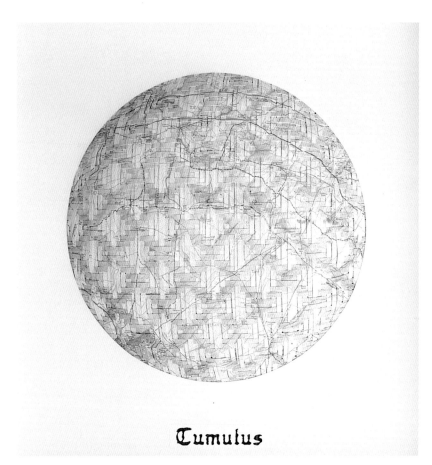

Tumulus

TUMULUS

woven maps,
one pigmented with sheep's droppings

1997

Opposite

COVERED TUMULUS

hazel branches over burial mound

Firle Down, Sussex, 1997

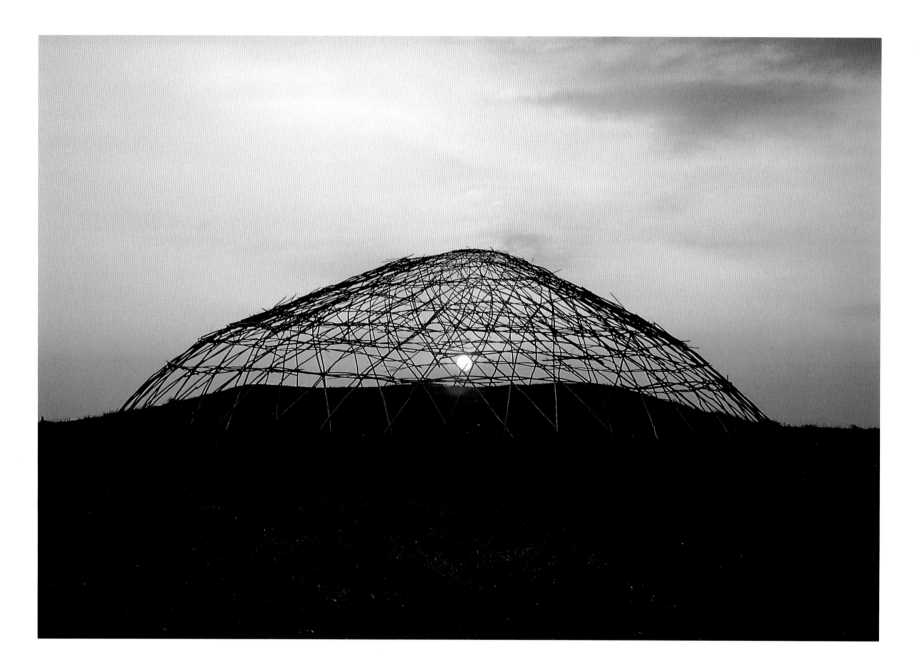

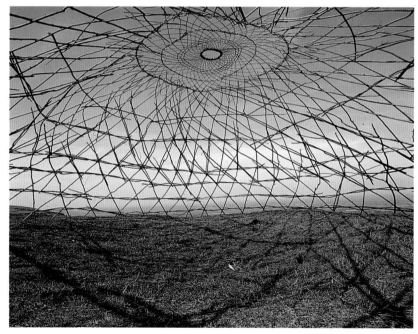

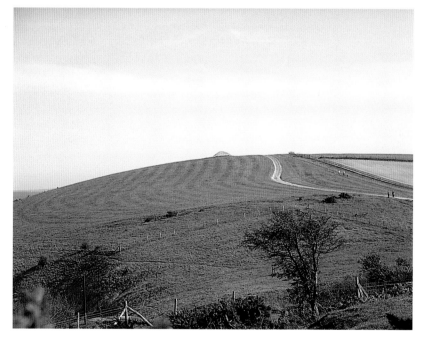

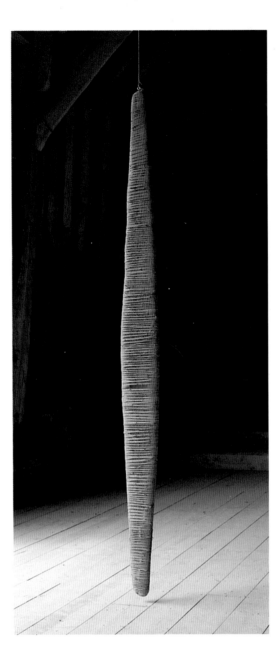

DRIFTWOOD BUNDLE

driftwood, willow bark

1994

Mahogany driftwood wrapped in the green bark of
willow, which, as it dried, turned reddish, shrank
and curled to reveal the wood beneath.

AIR VESSEL

willow

1994

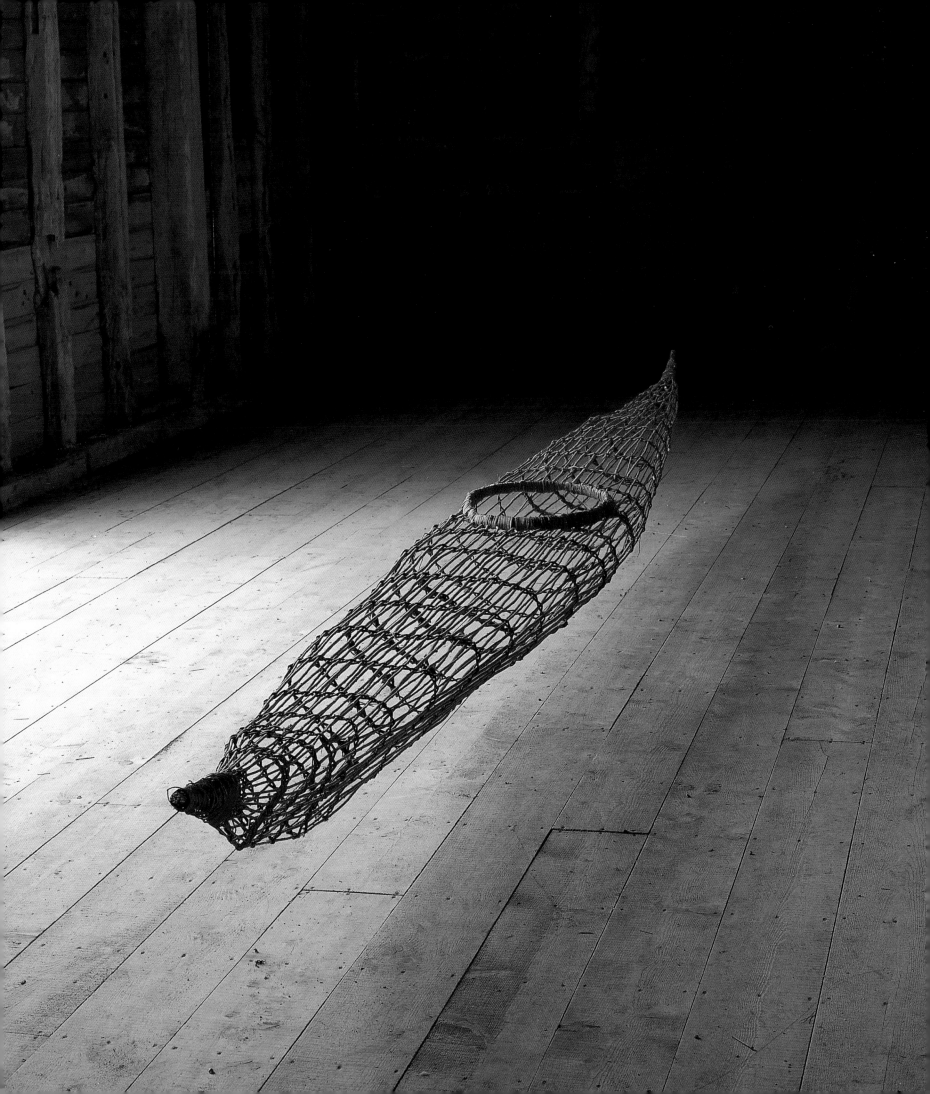

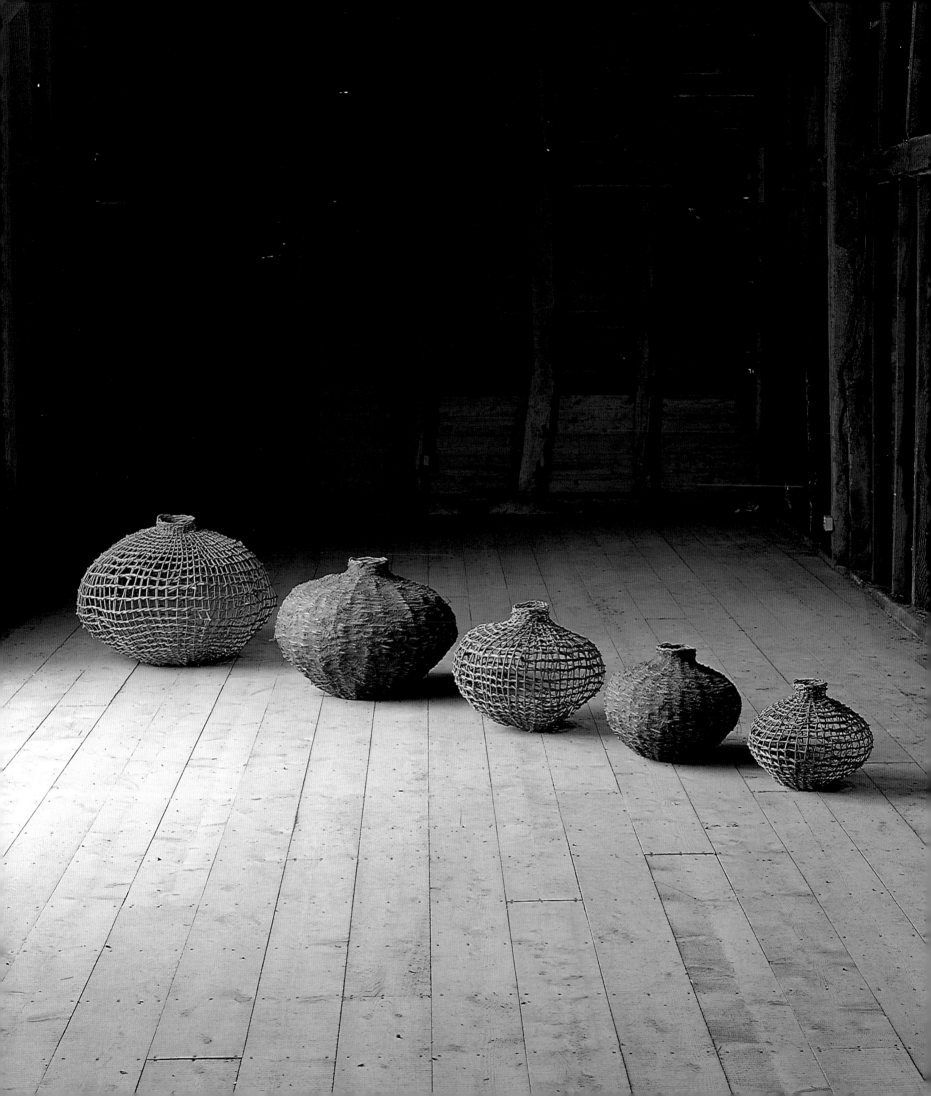

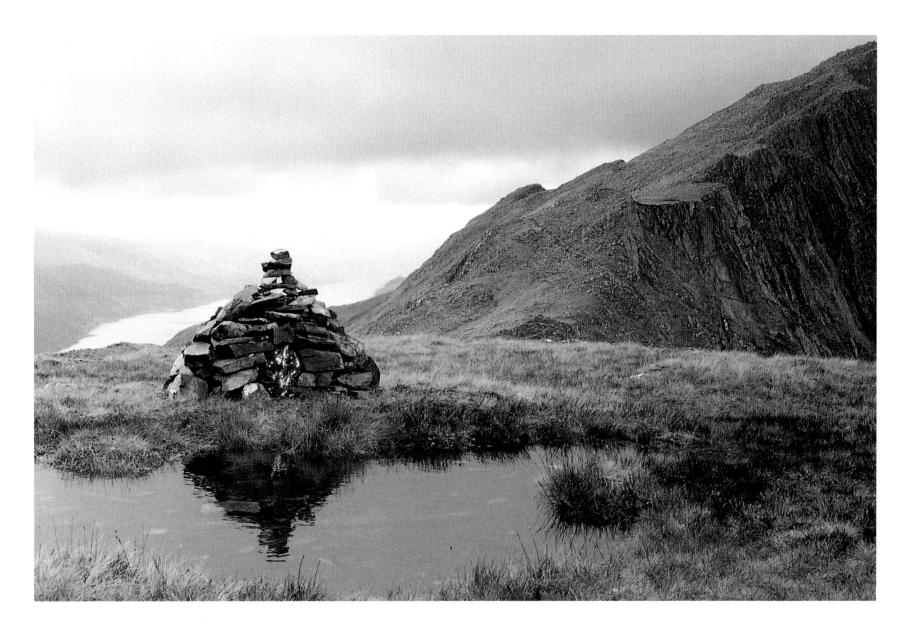

FIRE CAIRN

Five Sisters of Kintail, Glenshiel, Scotland, 1994

Opposite

FIVE SISTERS

willow and cow dung

1994

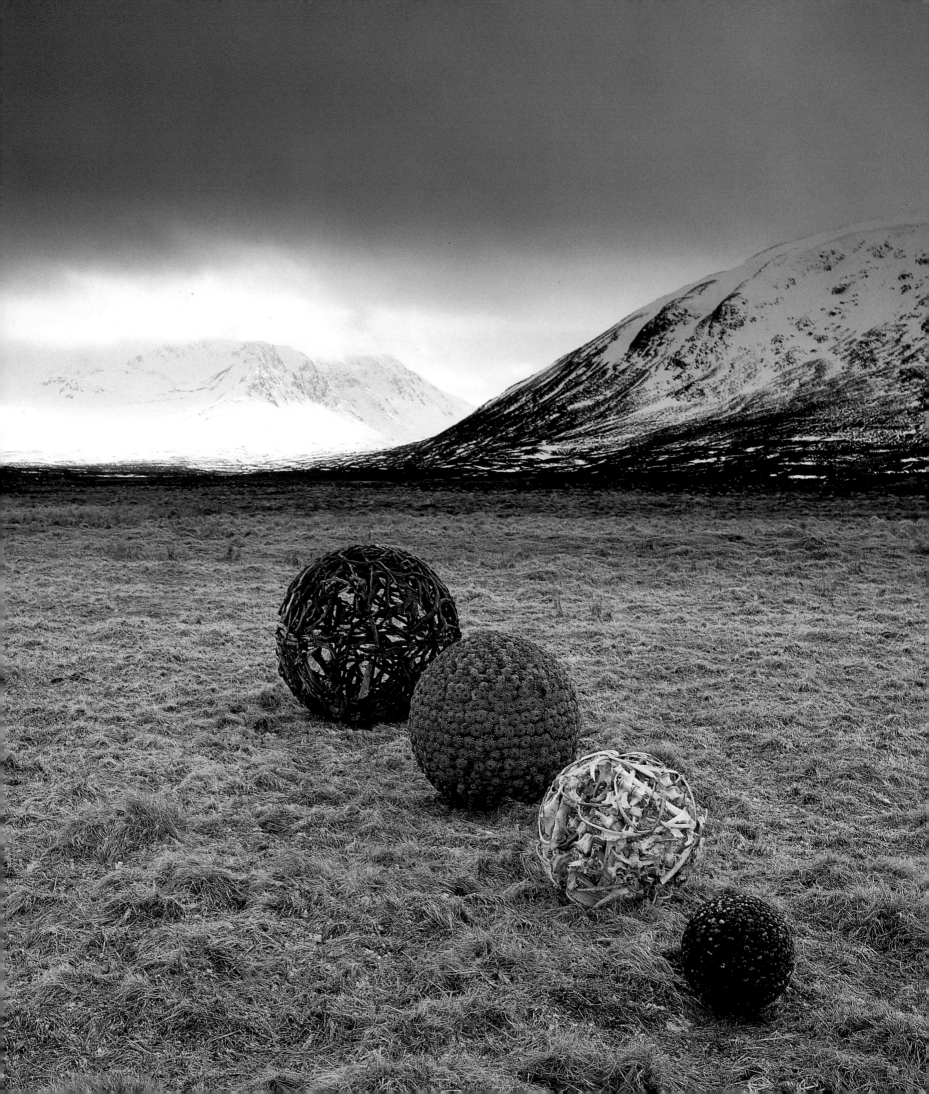

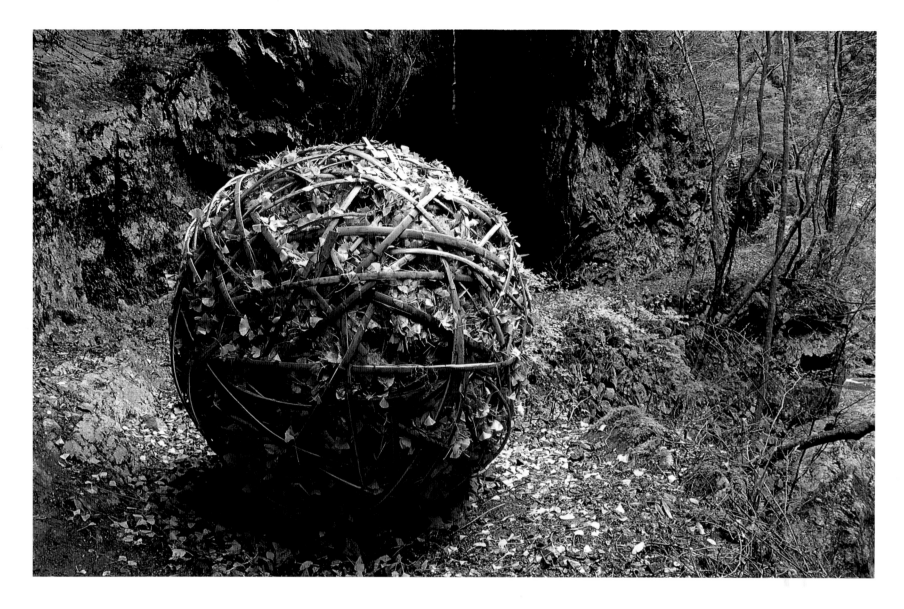

SHIMANTO RIVER SPHERES

bamboo and ginkgo leaves
bamboo and vine
bamboo, vine, moss and seeds
bamboo and vine
vine, moss and seeds

Higashitsuno-mura, Kochi Prefecture, Japan, 1997

Opposite

FOUR SPHERES

deer scats, deer bones, pine cones, pine 'bones' (roots dug
from the bogs, relics of the ancient Caledonian Forests)

Ben Alder, Grampian mountains, Scotland, 1984

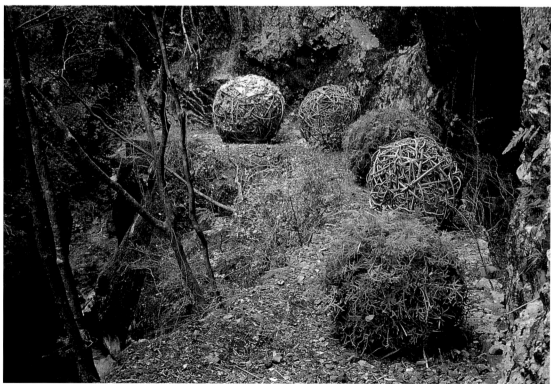

CAIRNS AND BUNDLES

In the seemingly empty Canadian tundra, the Inuit built cairns resembling people to ward off loneliness. The Saami of Lapland do the same – a tradition that has been extended by tourists in cars heading for North Cape. In Europe we mark trails and summits with stones. In other parts of the world cairns have religious significance and may contain a relic. They are also memorials to the dead.

In 1997, while walking in Ladakh, I saw many cairns which simply marked a place of significance: the first view of a village, the place to cross a river in order to see a rock carving. For me it was like coming home, for this is also the reason why I pile stones up: to mark a moment and place in time.

In Japan recently, at the end of a project on the Shimanto river, I decided, on the spur of the moment, to put four small river stones on top of one another on a rock in a turbulent part of the river. It took all of two minutes and was made because of the beauty of the water's flow in that place and my relief at having completed the project successfully. The cairn was a moment of stillness within movement. Although it was almost invisible against all the other stones, the many people visiting the place the next day noticed it, and pointed it out – grinned recognition across cultures.

If a shelter is a stopping place, a full stop, a cairn is a comma within the rhythm of a walk. Against the background of the meditative action of walking, cairns are markers of highpoints/moments of exhilaration along the way. Three minutes to mark with stones, three minutes to photograph, knock the cairn down and walk on, the gesture communicated later by the photograph.

A fire cairn is a longer pause, a breathing in. It may take up to an hour to build and will be made as contrast: fire and water, ice and fire; or as accentuation – fire and sunrise/sunset. The bread oven at St James's, Piccadilly, in London, was both an echo of fire cairns in remote places and a means for the homeless to boil a kettle, stay warm.

I have moved objects ritually from place to place – driftwood from the sea taken to the top of a mountain, flower petals from a mountain in Sri Lanka taken to the other end of the island, a whale bone picked up on a beach, placed atop a cairn on a clifftop facing the sea, then carried home, revitalised, scored, and rubbed with earth to become a relic or talisman of place. A similar work was made in New Mexico with an elk bone taken from a litter of many bones at the killing place, the kitchen, of a mountain lion – a place to step warily, a place to respect.

Bundles are more literal – a stick, a stone, a bone, wrapped or wound with grass, roots, etc. Like the cairns, they are talismans of time and place, souvenirs, made simply at a campsite, or alternatively made at a later date as an act of remembering. A stick is a forest, a stone a mountain. The existence of a cairn is recorded by a photograph – a historical moment; a bundle, by its continued existence, carries experiences into present time.

Tidelines (*see* pages 14-15) is not bound to place, but provoked by found words as well as found objects. The idea came from something I had written on my studio wall, 'wave wind cloud moon breath' next to a small, circular pencil tracing of wave patterns left by the retreating tide on sand. (Some words have a resonance beyond their obvious meaning. I think they must be buried deep in our psyche.) It was the germ of an idea, but incomplete, so I left it to stew. Several months went by. One day I was walking on a local beach looking down at the clutter of flotsam washed up by the tide and was struck by the thought that it was those elements (wave, wind, cloud, moon) which had brought these objects to this spot, and that the tide is the breath of the sea.

DRIFTWOOD CAIRN

stacked driftwood and reindeer antler

Kvaløya Island, North Norway, 1988

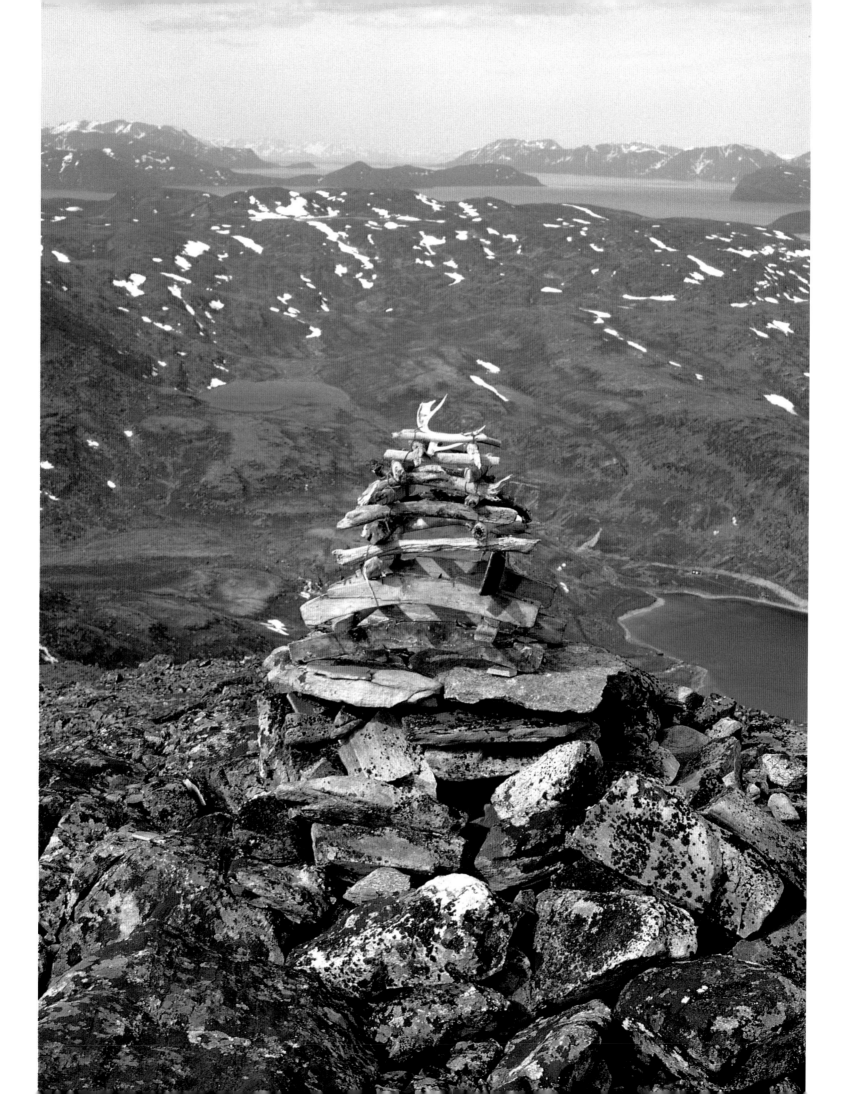

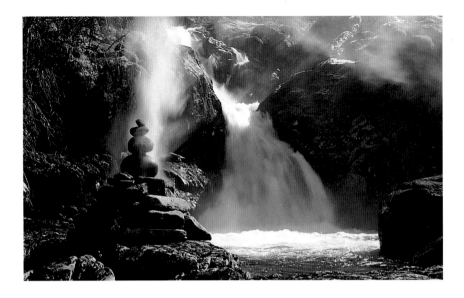

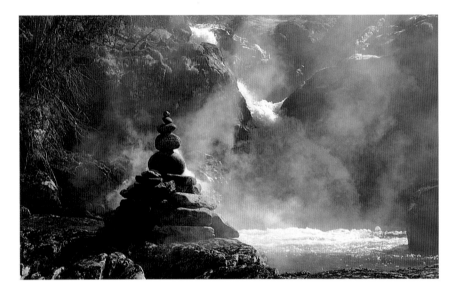

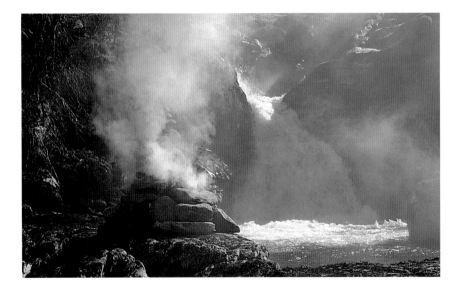

FALLING WATER FIRE CAIRN

Rosendal, Norway, 1997

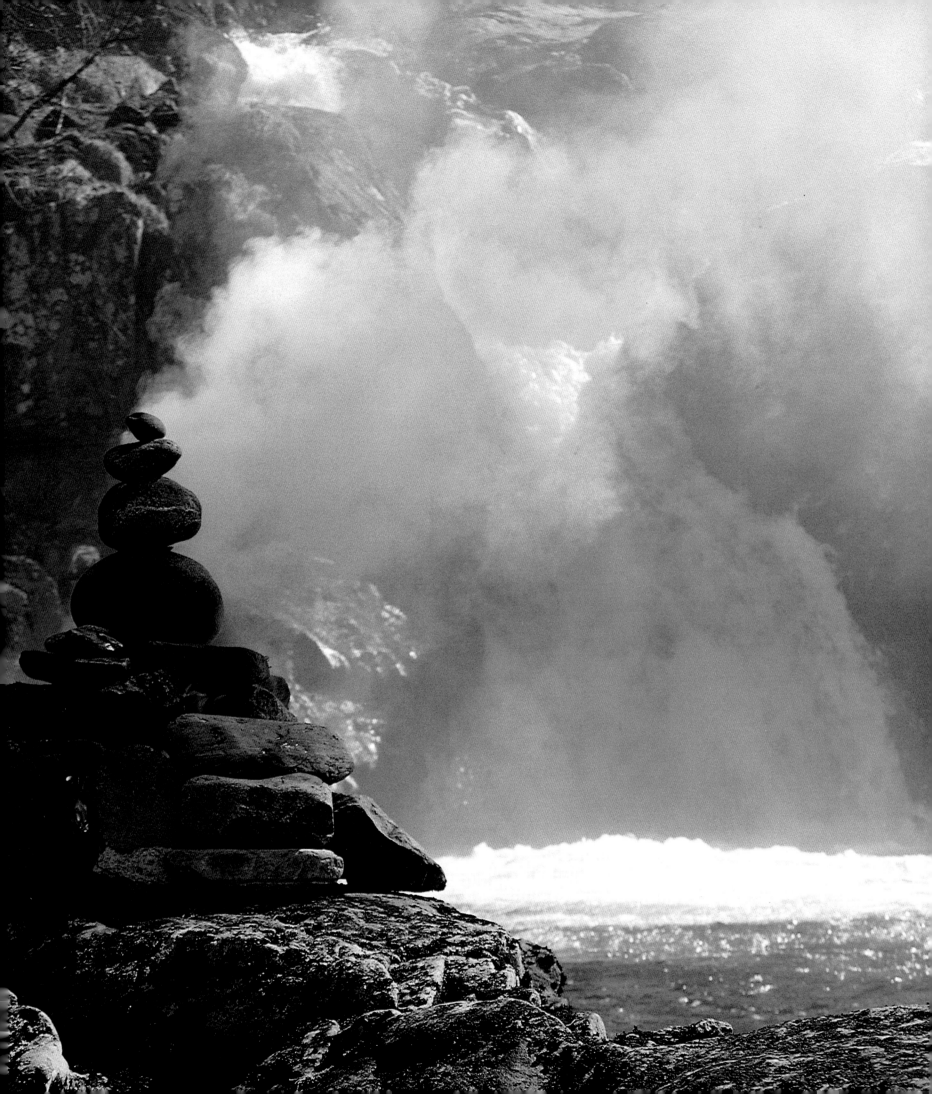

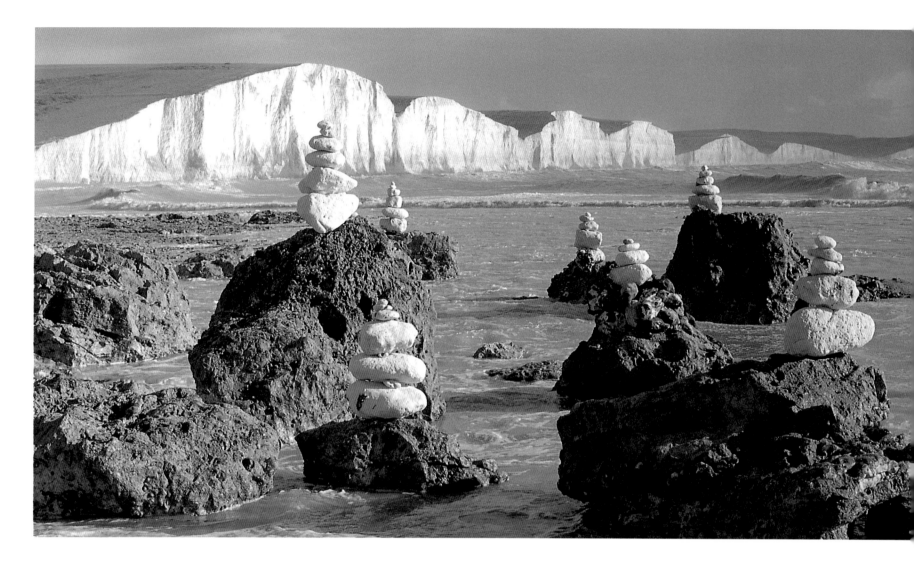

SEVEN SISTERS CAIRNS

chalk boulders

Sussex, 1995

SEVEN SISTERS BUNDLES

six pieces of driftwood and one of flint, marked with chalk
and bound with fishing twine

1994

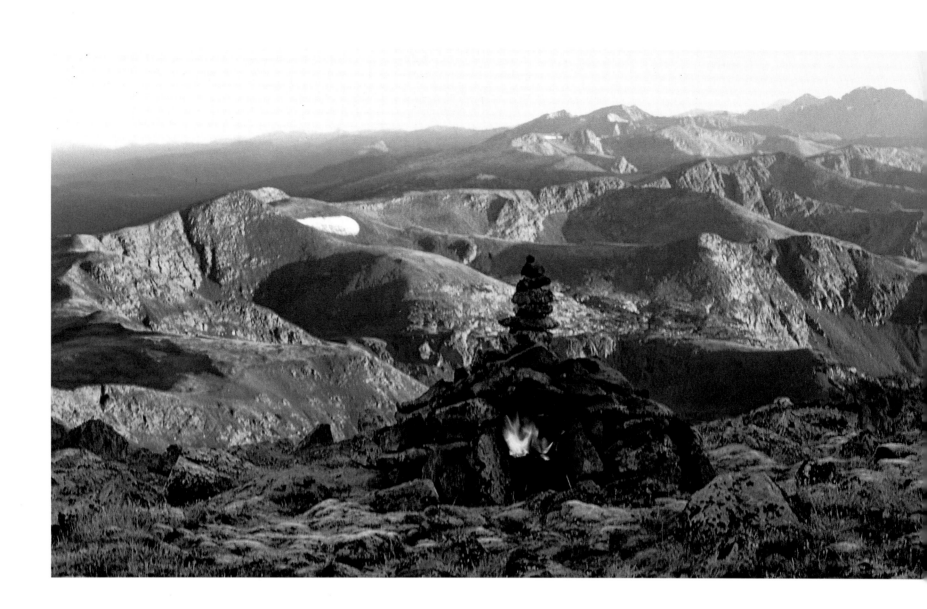

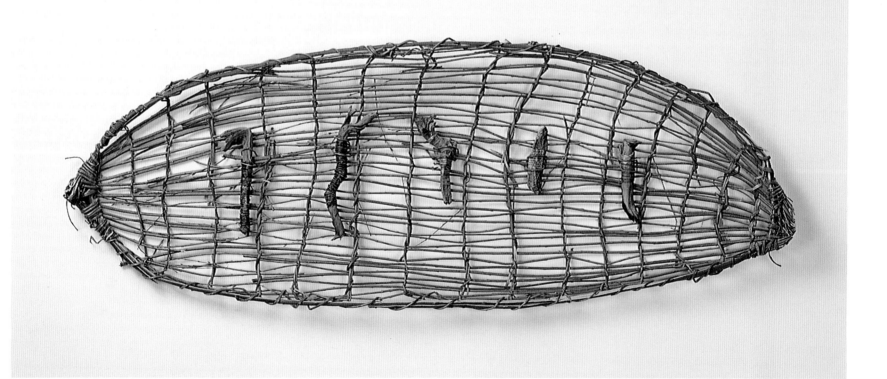

A five-day walk along the Continental Divide – four of the seven cairns built
along the way and a bundle for each campsite.

Left

FIRE CAIRN

James Peak, Indian Peaks Wilderness, Colorado, 1989

Opposite, below

COLORADO CAMPSITE BUNDLES

etched stone, sticks bound with grasses, rush and blue willow
on a woven willow tray

1989

Below

THREE CAIRNS

Indian Peaks Wilderness, Colorado, 1989

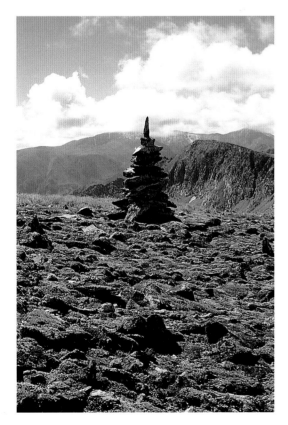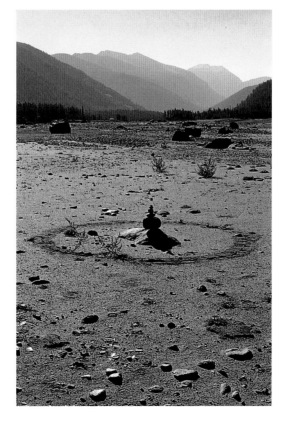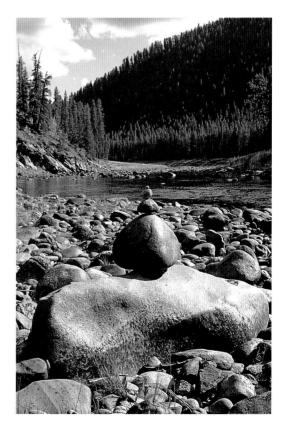

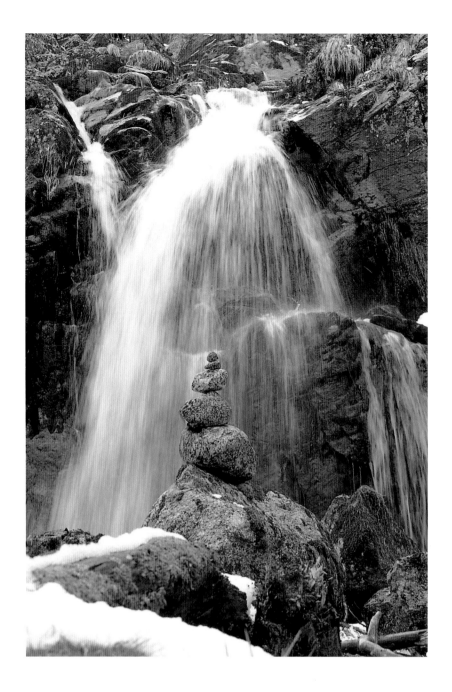

MOVING WATER, RESTING STONES

Rosendal, Norway, 1997

Opposite

KHARDUNG VALLEY CAIRN

Ladakh, 1997

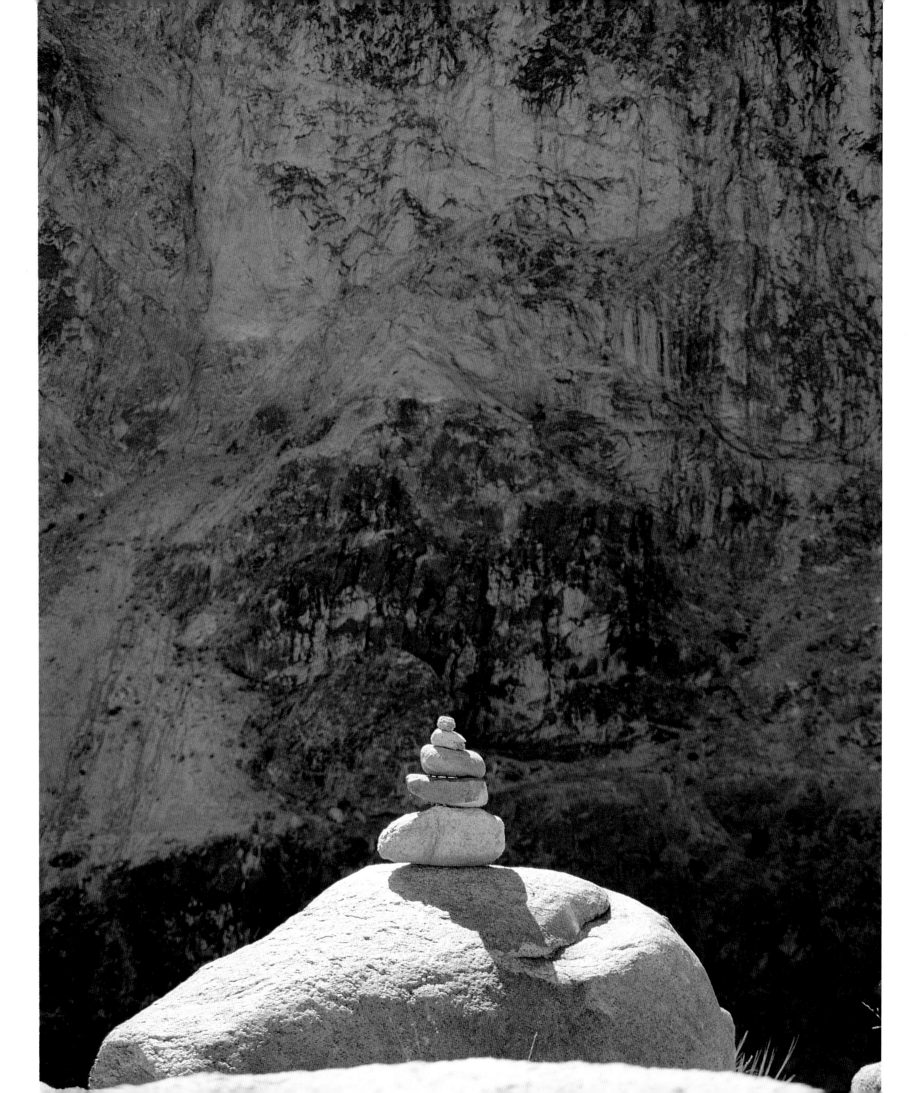

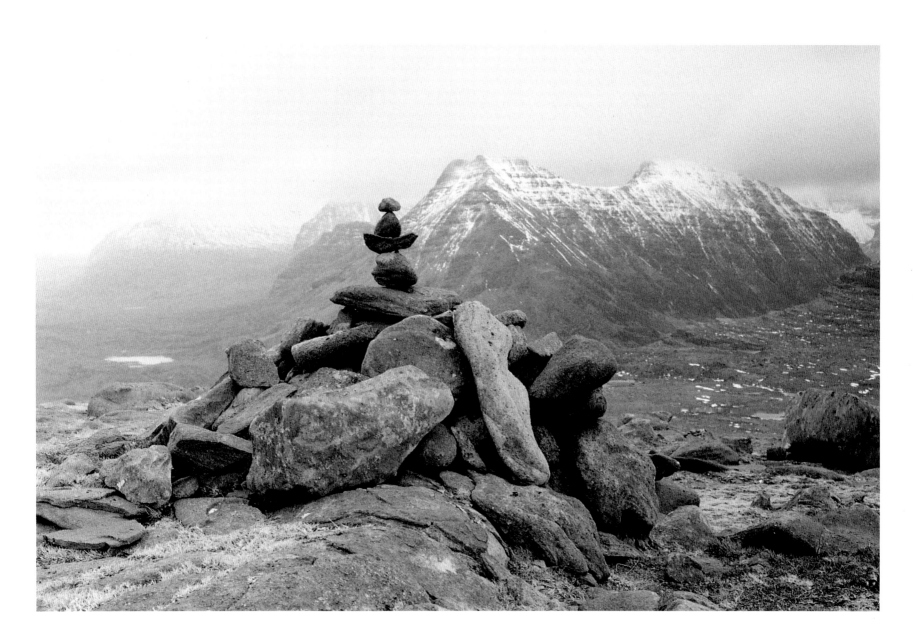

BEINN ALLIGIN CAIRN

Wester Ross, Scotland, 1992

Opposite

STICK BUNDLE

stone, stick, roots, birch bark,

collected in Wester Ross, Scotland

1992

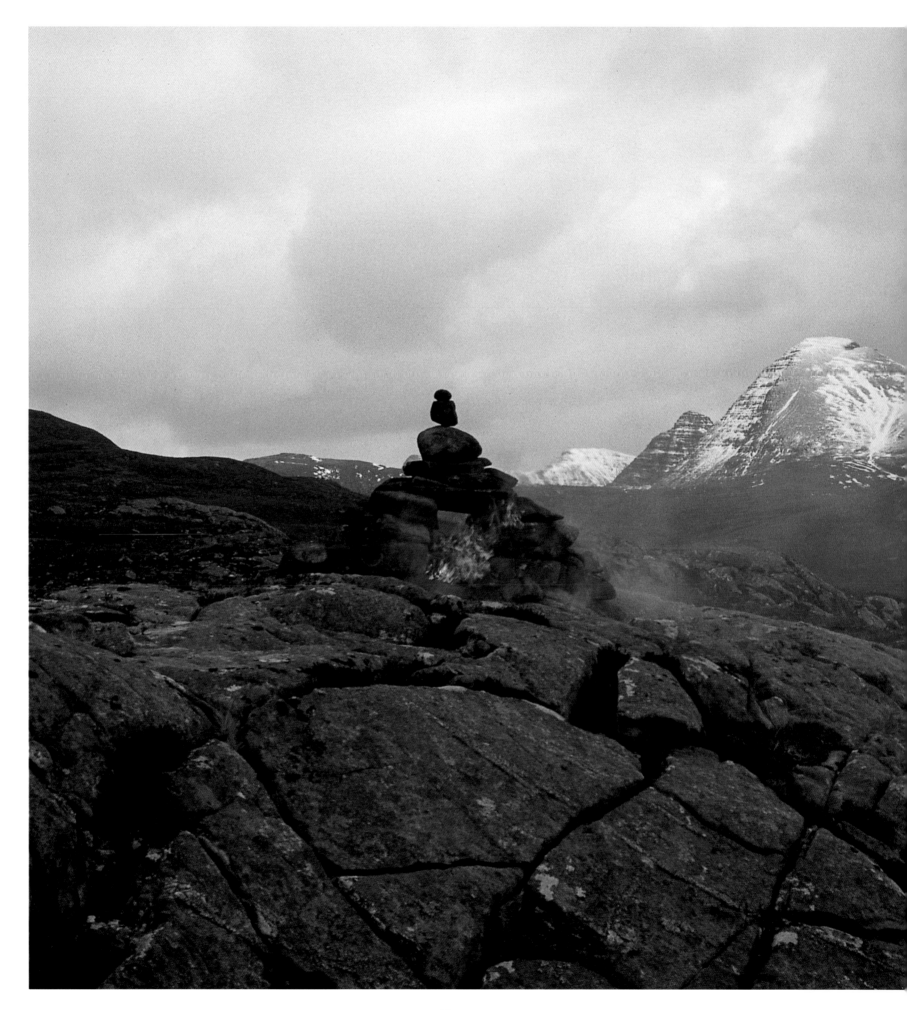

FIRE CAIRN

Shieldaig Forest, Wester Ross, Scotland, 1992

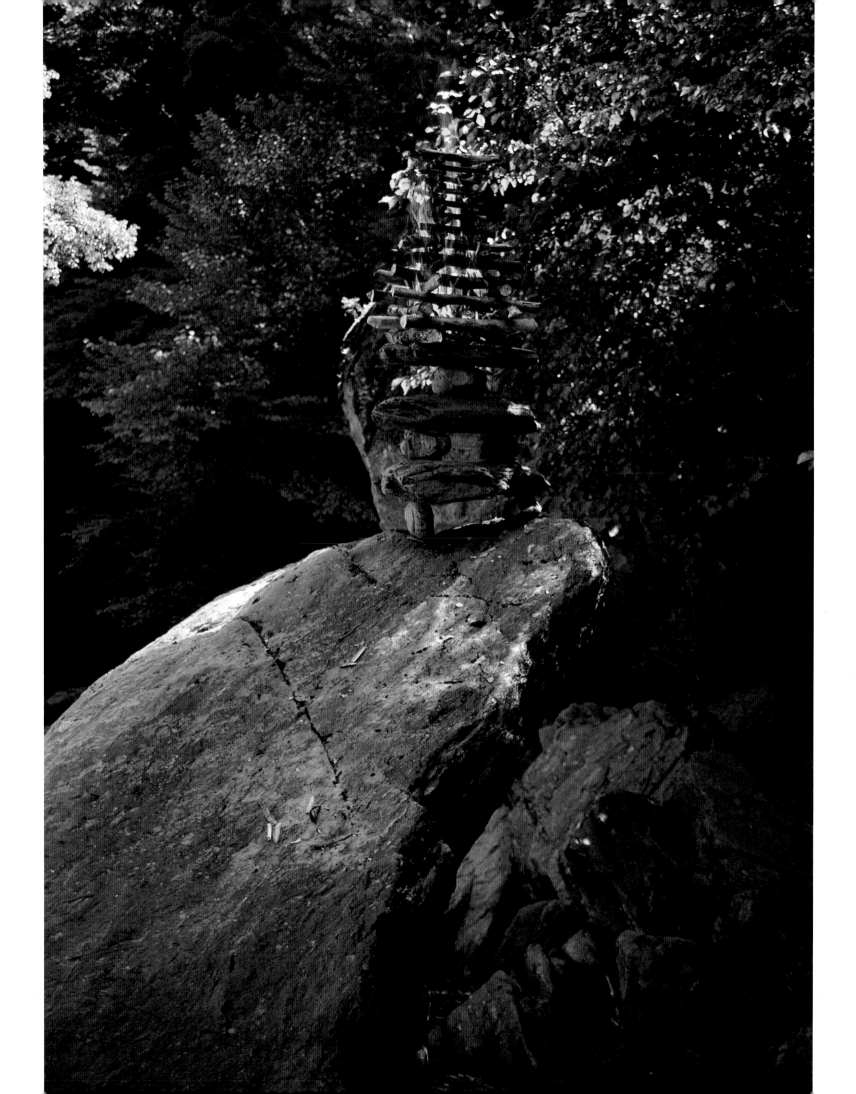

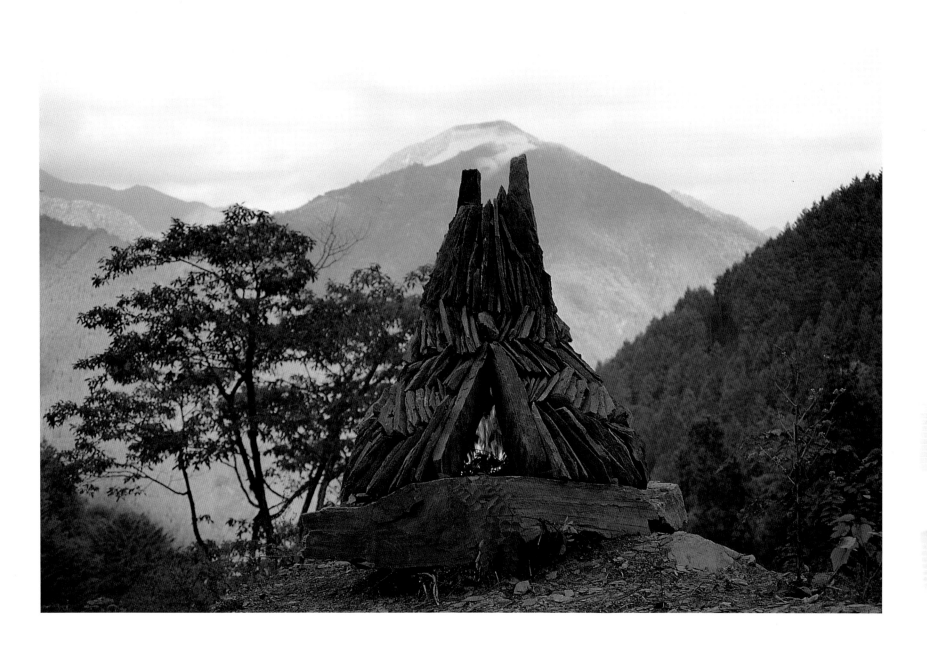

FIRE MOUNTAIN CAIRN

Okawa-mura, Kochi Prefecture, Japan, 1996

Opposite

RIVER FIRE CAIRN

stacked stone, stacked sticks

Okawa-mura, Kochi Prefecture, Japan, 1996

73

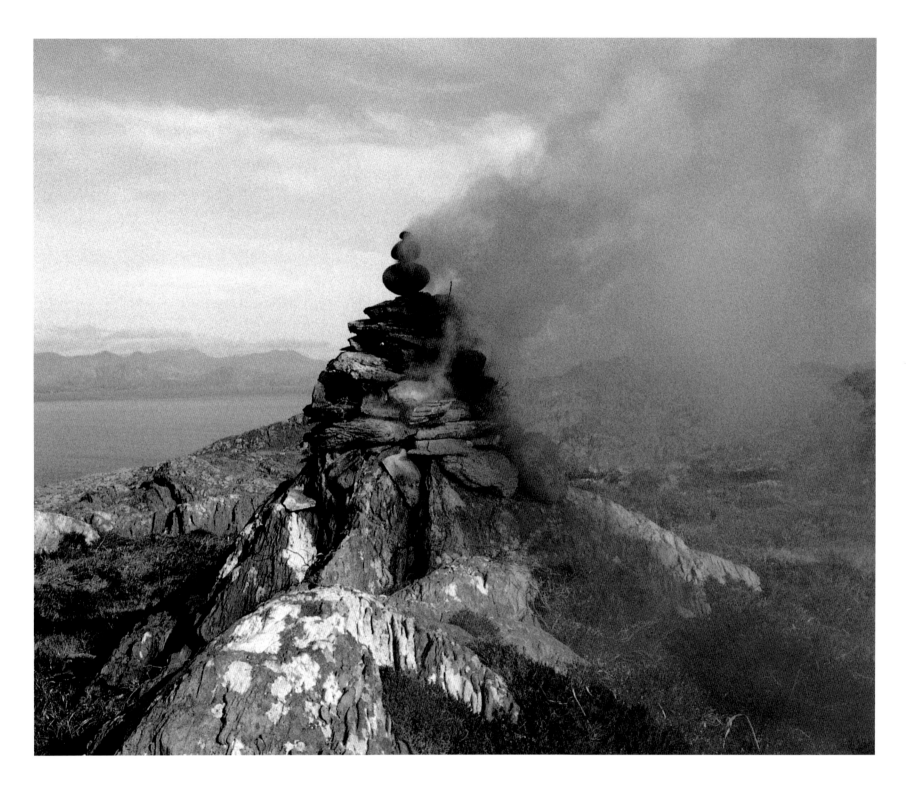

FIRE CAIRN

Cod's Head, Beara Peninsula, West Cork, Ireland, 1993

ALLIHIES BONE AND WOOL
BUNDLES

bone, wood, wool, stone

1993

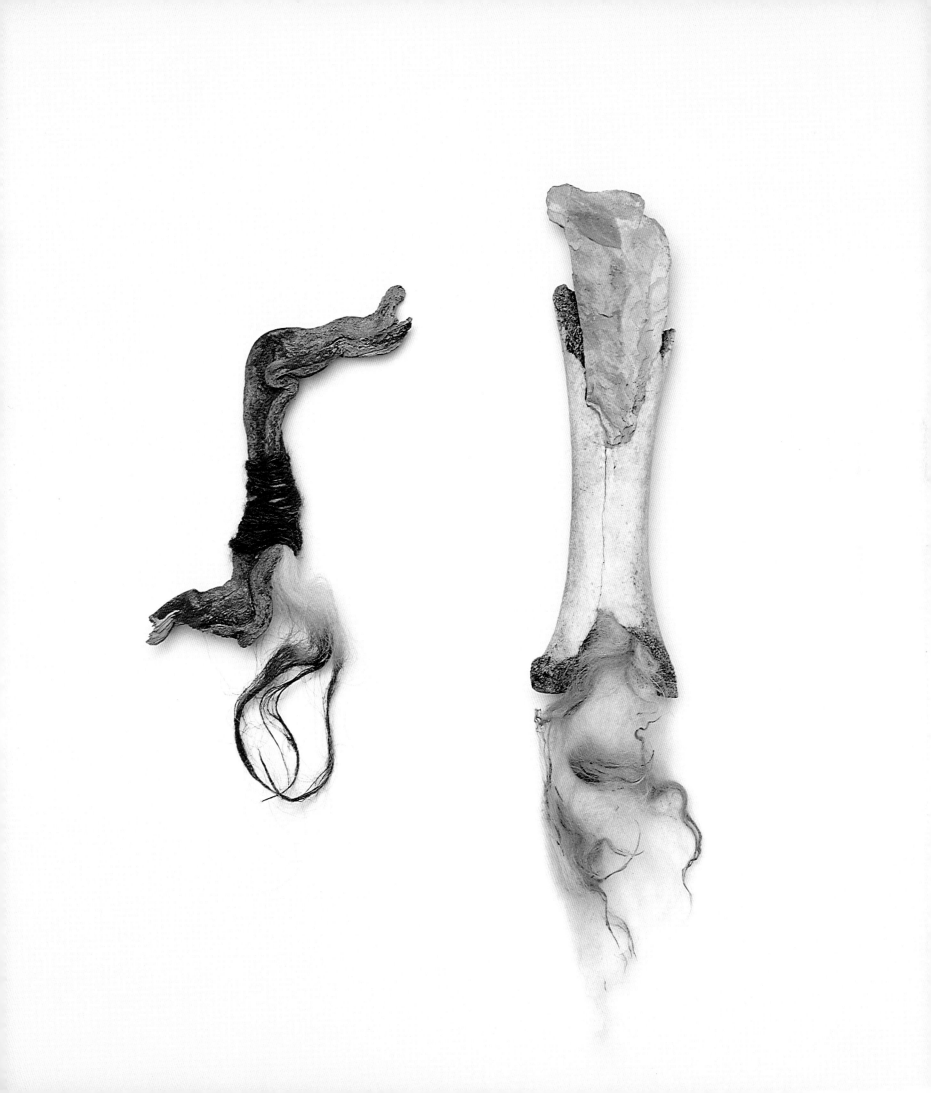

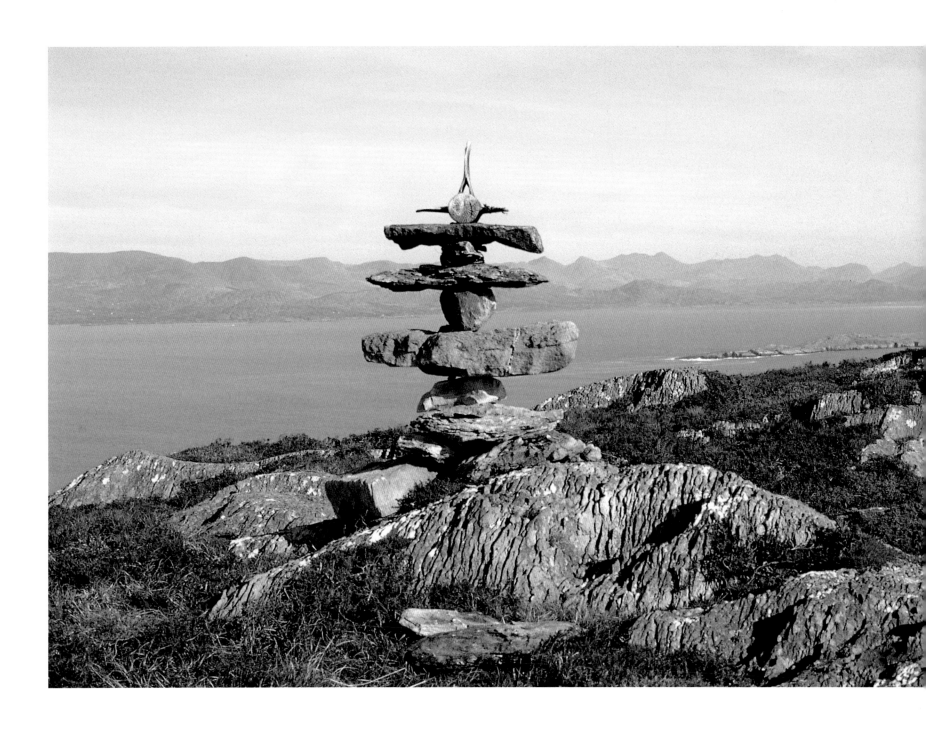

WHALE BONE CAIRN

Beara Peninsula, West Cork, Ireland, 1993

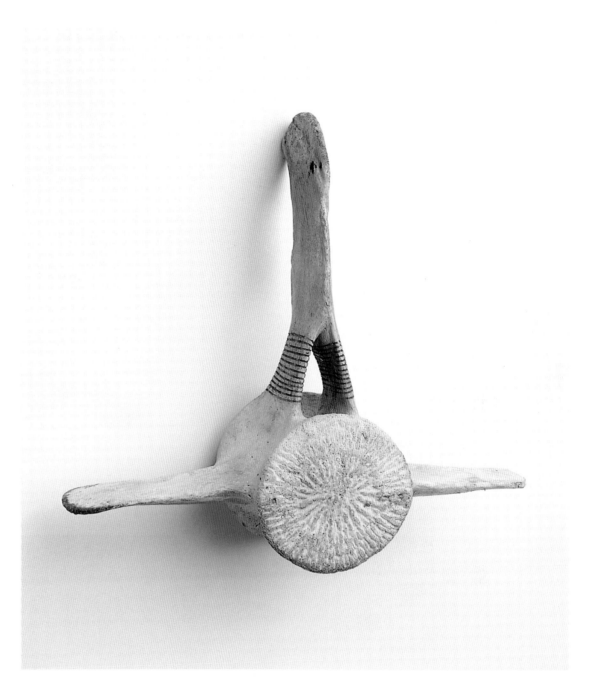

WHALE BONE

pilot whale vertebra etched with ochre

1993

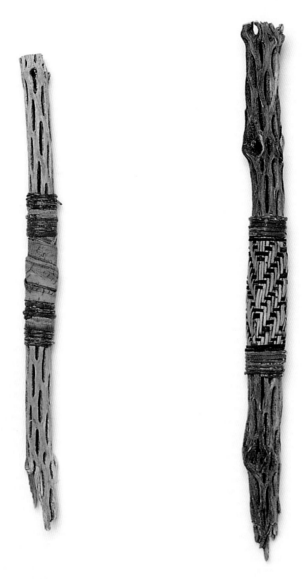

CHOLLA BUNDLES

cholla sticks bound with willow and yucca

New Mexico, 1993

Opposite, above

MOUNTAIN LION CAIRN

Bandelier Wilderness, New Mexico, 1993

below

LION KILL BONES

etched elk bones, earth

1993

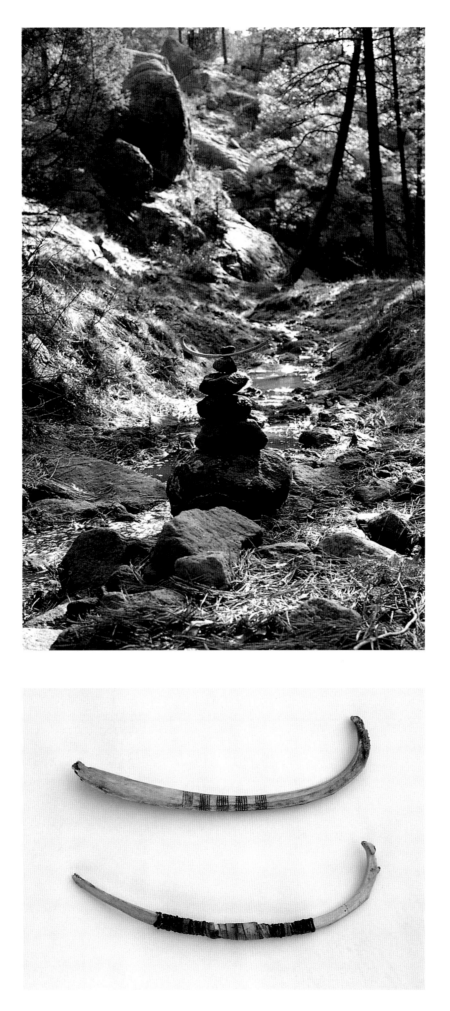

COVERED CAIRN

hazel, willow, stone

Tickon, Langeland, Denmark, 1993

Tranekær Castle, on the island of Langeland, is the oldest castle in Denmark. Its park is based on nineteenth-century English designs, and therefore on a historical, romantic view of nature. In the twentieth century, the dominant view of nature and the landscape, informed by ecopolitics, has become more pragmatic, but the division between art and nature still exists, as it always will: the moment you think about nature, you are imposing upon it language and ideas.

My work usually points to something outside or beyond itself. At all public sites devoted to art, one is presented with a cultural veil. In this park, I was effectively dealing with two - the historical and the contemporary. Cairns in more remote places refer to time and place. Here at the International Centre for Art and Nature, I decided to mark not simply the surroundings, but also an interior, by making a covered cairn. The woven dome is a division between outside and in, which nevertheless allows a transition from one to the other, a free flow of inner to outer. The experience inside it is different from the experience outside.

The dome was woven from hazel running in one direction, willow in the other. While the hazel would die, the willow would strike and grow. The work was to be allowed to go its own way, and I predicted that in time there would be a thicket of willow surrounding the fallen boulders of the cairn. In other words, I had imposed a geometric order which would revert to chaos, the true order of nature. Unfortunately it reverted to chaos sooner than anticipated: the deer in the park ate it in the spring and butted holes in it during the rut.

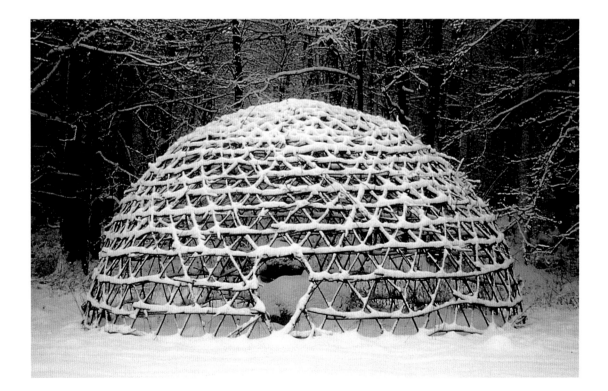

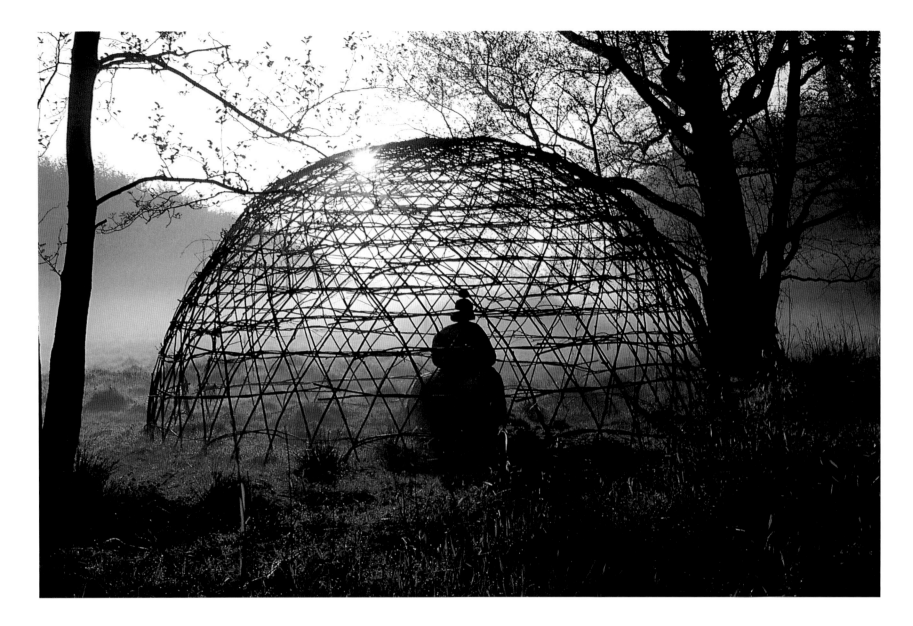

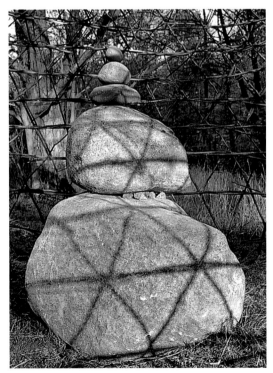

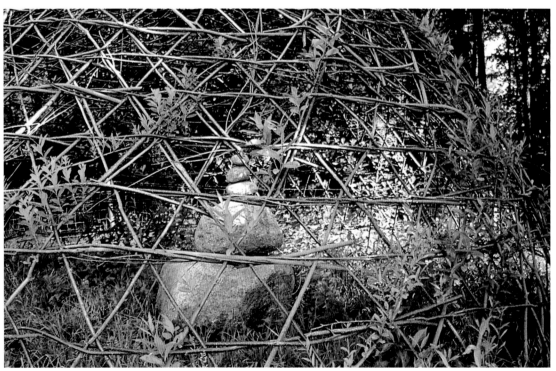

EARTH, MUSHROOMS, PLANTS, TREES

In the summer of 1983, the year that Medicine Wheel came full circle, I noticed a strange plant growing on some waste ground near my home. I have very little scientific knowledge of plants, but have always been fascinated by them, particularly by how they grow and find their place in the world, a place that suits them. This particular plant was striking. It looked strong and vigorous and had small, purple-black flowers. It was powerful, like a tree is, or a wild cat. Although I had never seen one, the word Belladonna presented itself. I looked it up at home and was proved correct. Large quantities of this plant – deadly nightshade – will kill you, a critical quantity will give you hallucinations, make you see the world in a different way. Very small amounts will heal you. Belladonna has many medicinal uses, but is particularly good for fevers.

The fact that this plant had attracted my attention so forcefully made me wonder if other plants with similar kill-and-cure properties also had the power to attract. I spent the next four months keeping an eye out for plants, collecting and identifying. I had a success rate of about fifty per cent in trying to guess which plants were poisonous/medicinal. Of course, a scientific knowledge of plants is essential if you want to use them. I would maintain, though, that there exists a kind of aura about these plants – not to be trusted, however. In Japan, I was tempted to eat some delicious-looking berries, until I was informed that they were deadly.

At the end of that summer of 1983, I boiled up the leaves and stems and roots of the plants I had collected to make a paper pulp bowl, and threw in the seeds, flowers and berries to make the work Medicine Basket.

The work Hidden and Revealed, made in 1994, speaks more of knowledge than of intuition. Here the plants themselves are all wrapped and hidden by burdock leaves, and labelled with their Latin names. With knowledge, the information can be put to practical use. To most of us a plant is just a plant, maybe hardly even noticed, therefore invisible, hidden. To someone who has inherited a thousand years of practical knowledge, the plant is readily visible and of use. In time, these plants will disintegrate to dust in their box frames, and only their names and, with luck, some knowledge of their properties will remain.

The whole plant world, from soil to tree to mushroom and back to soil again, intrigues me. It is our primary connection to the outer world. Plants are the basis of the food chain, tying us irreversibly to the soil. The tree is the conduit of the earth-water-air cycle as well as being the archetypal cultural image of transformation from dark to light, underworld to heaven.

THE MONTHS

detail from the centre of Medicine Wheel

photographed immediately after completion

spore print and plant pulp papers

1983

September: reed, dock, blackberry, various seed heads; *October:* reed, blackberry, nettle, rosehips;
November: reed, mixed autumn leaves, rosehips, black bryony berries;
December: reed, ivy, leaf mould, dock root; *January:* reed, mixed grasses, dead leaves, parsnip root, carrot root;
February: reed, moss, dock roots, comfrey roots; *March:* reed, sedge, nettle;
May: reed, nettle, bracken, bluebell; *June:* reed, dock, nettle, burdock, hogweed, cow parsley;
July: mixed perennial grasses; *August:* wheatstraw.

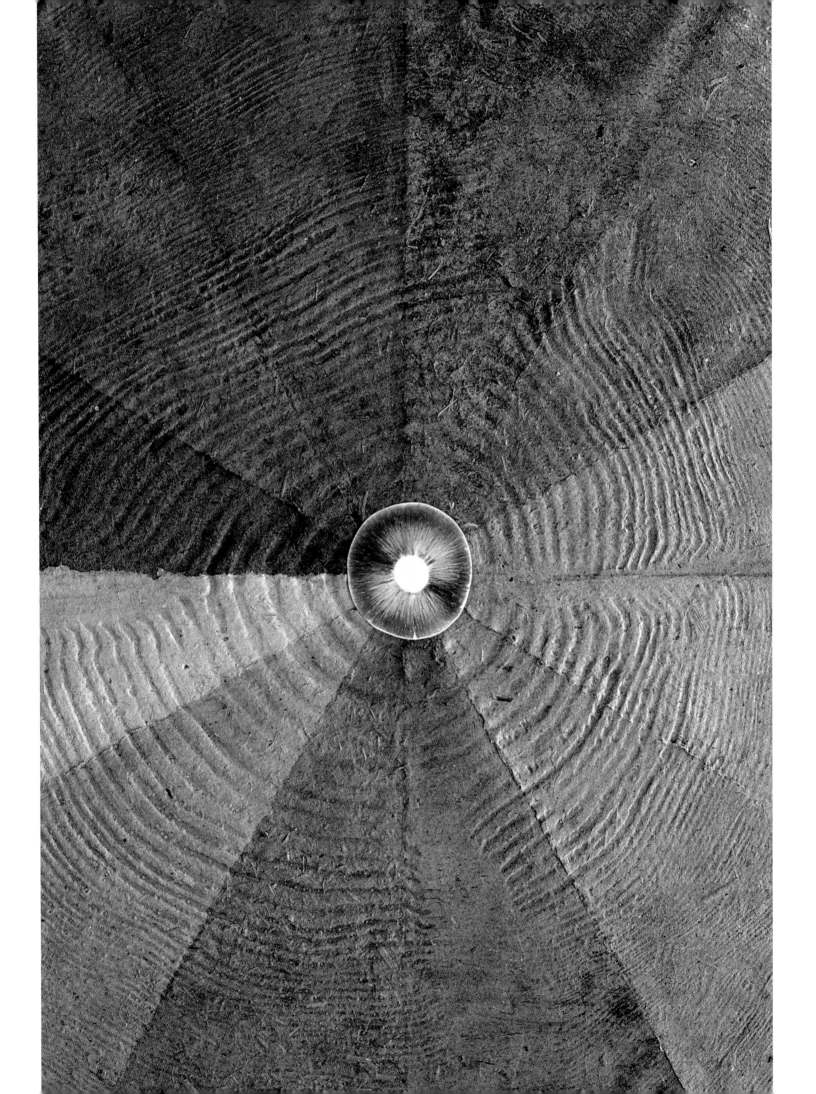

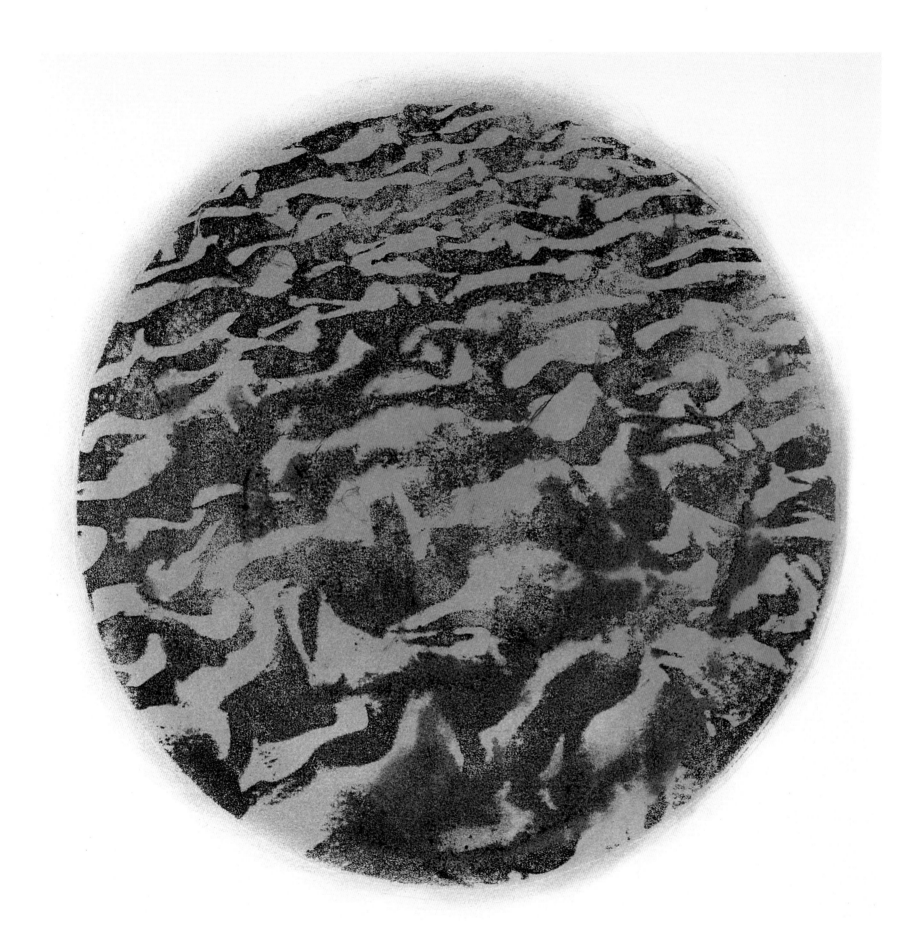

EARTH WAVE DRAWING

image of wave patterns printed in black ink on a rubbed earth pigment from Watergrove, Lancashire.

1996

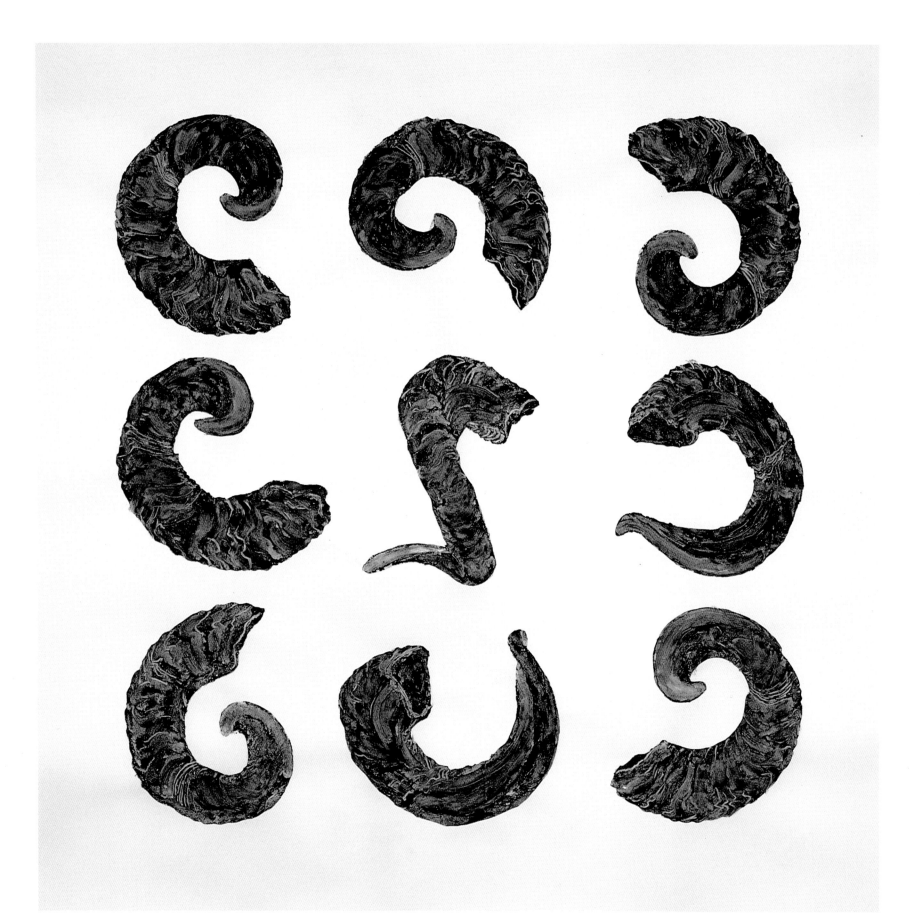

ADHARC DRAWING

peat smeared on paper with thumb and stick

1992

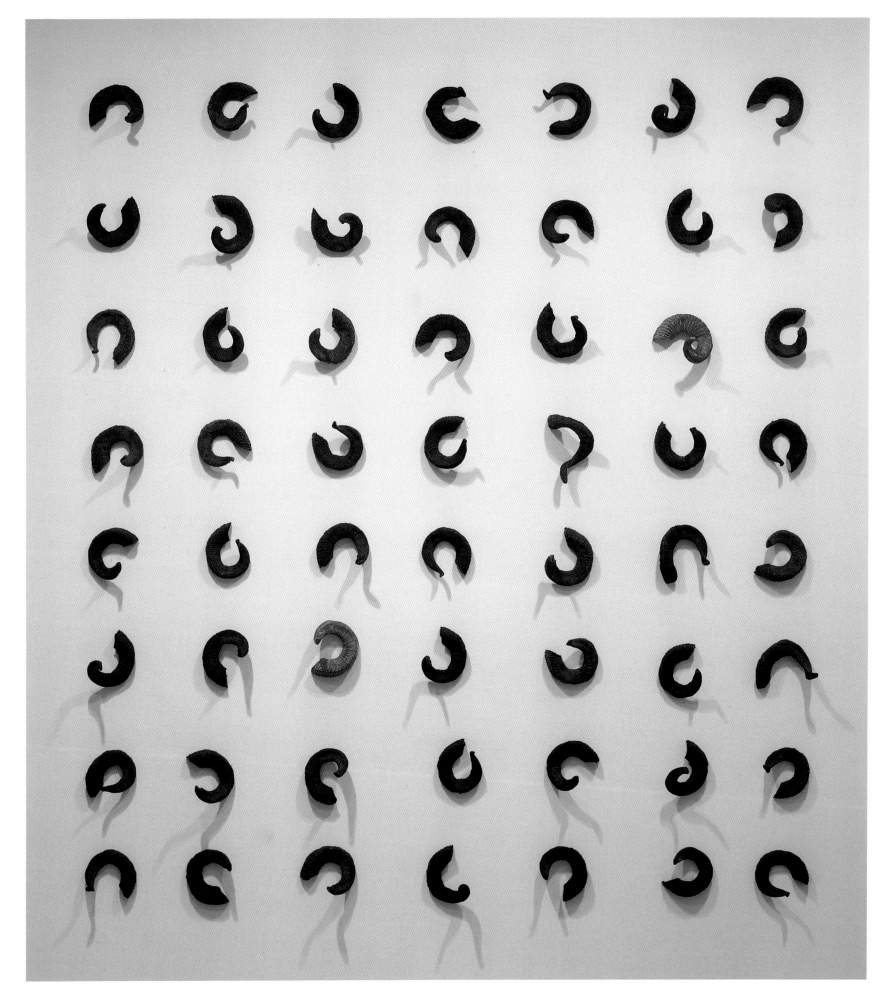

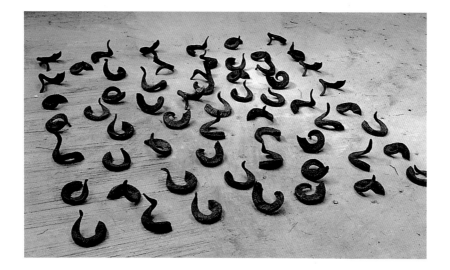

ADHARC I

two bronze and fifty-six peat horns,
all cast from a pair of ram's horns found on a beach in West Cork, Ireland

1992

In the summer of 1990 I took part in the Bogland Symposium in the Wicklow Mountains above Dublin. The Symposium opened in a pub, and it was here that I heard a bronze replica of the *adharc* (horn) being played for the first time. (The *adharc* is a three-sectioned bronze horn, thought to be 2,000 years old, which was found preserved in peat bog.)

Played like a didgeridoo, it speaks directly of the land, a voice that seems to emanate from the bogs. It is one of the most evocative sounds I know. I spent three weeks working on and with a bog, but it was not until later that summer, when I found two rams' horns on a beach in West Cork, that I was able to put the three elements together: bronze horn, ram's horn and turf (peat).

ADHARC II

heather, peat, PVA and bronze

1991

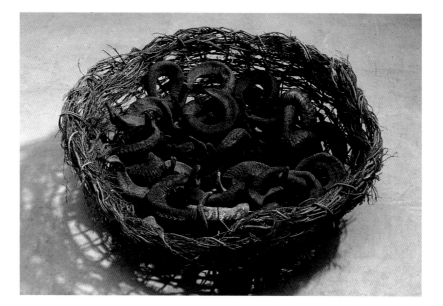

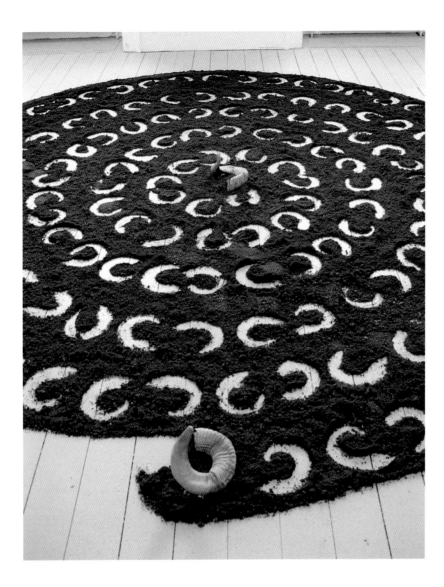

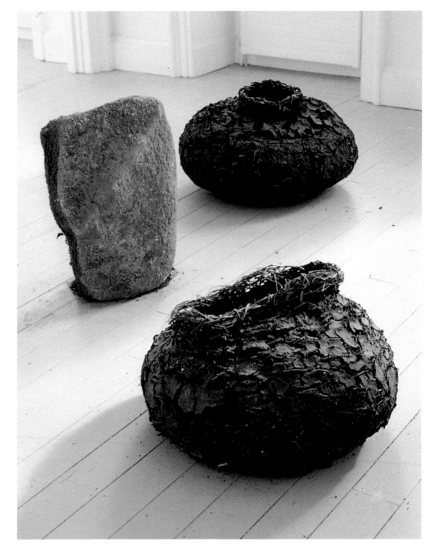

ADHARC III

rams' horns and peat

1991

TURF VESSELS

heather branches and peat

1991

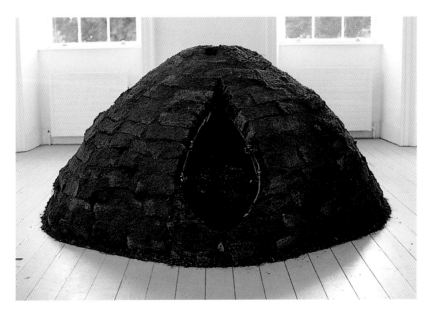

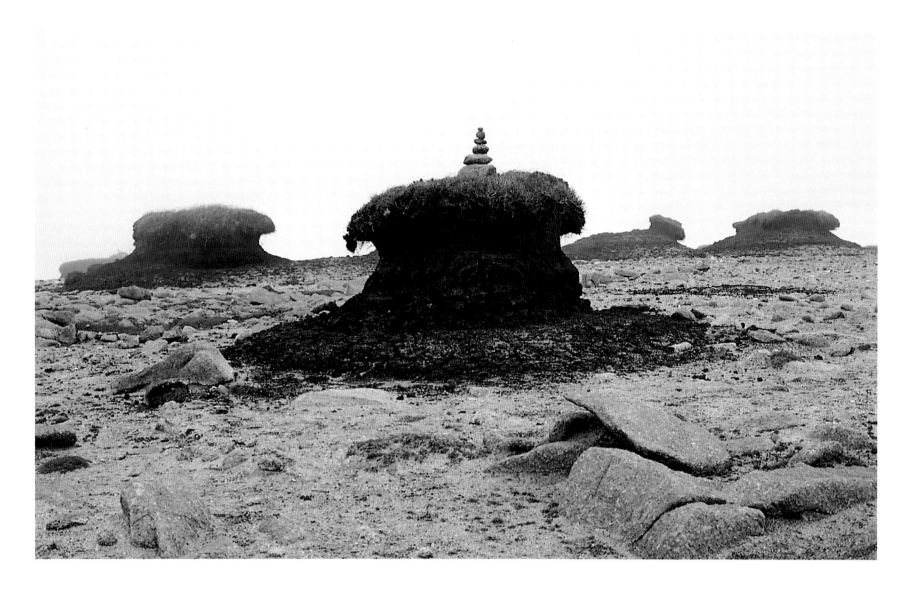

TURF CAIRN

cairn on eroded peat bog

Wicklow Mountains, Ireland, 1990

Opposite, below

TURF CHAMBER

turves over hazel frame constructed around boulder

1992

Overleaf

MUSHROOM CIRCLES

spore print and ink on paper

1993

All the varieties found in northern Europe of brown-spored mushrooms (*left*)
and white-spored mushrooms (*right*).

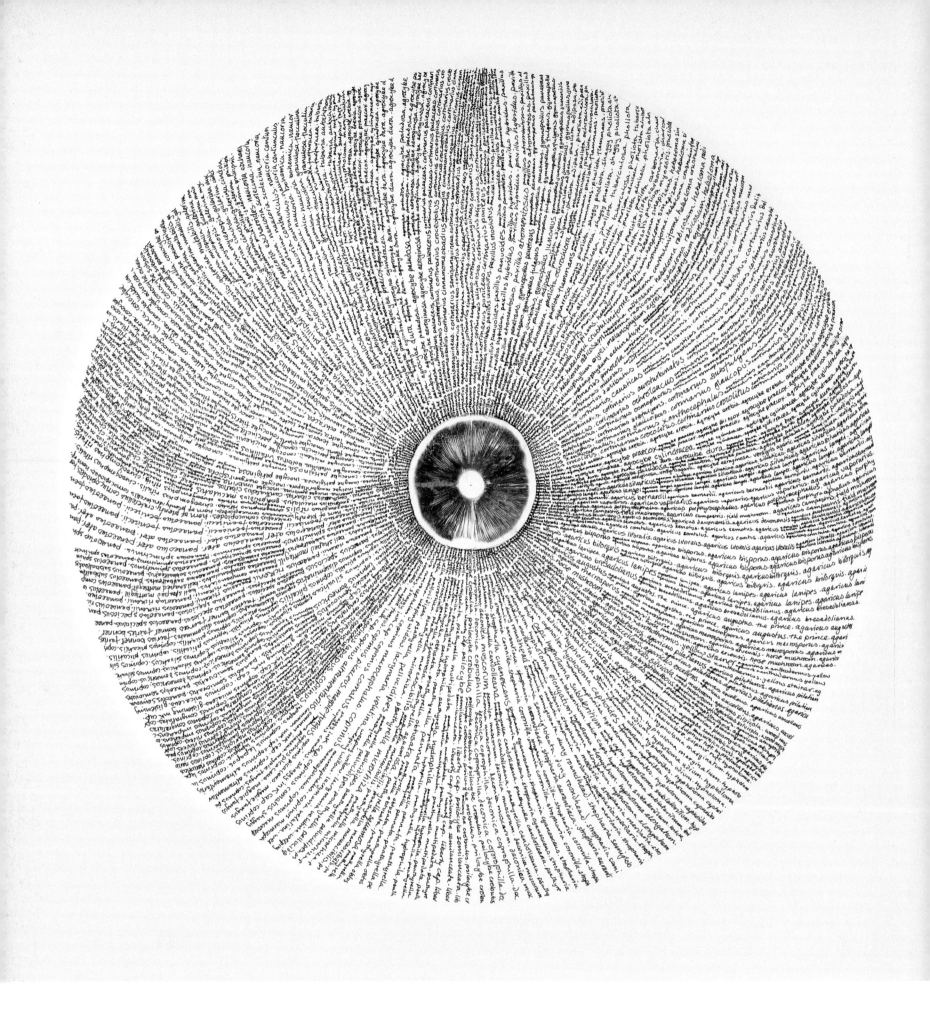

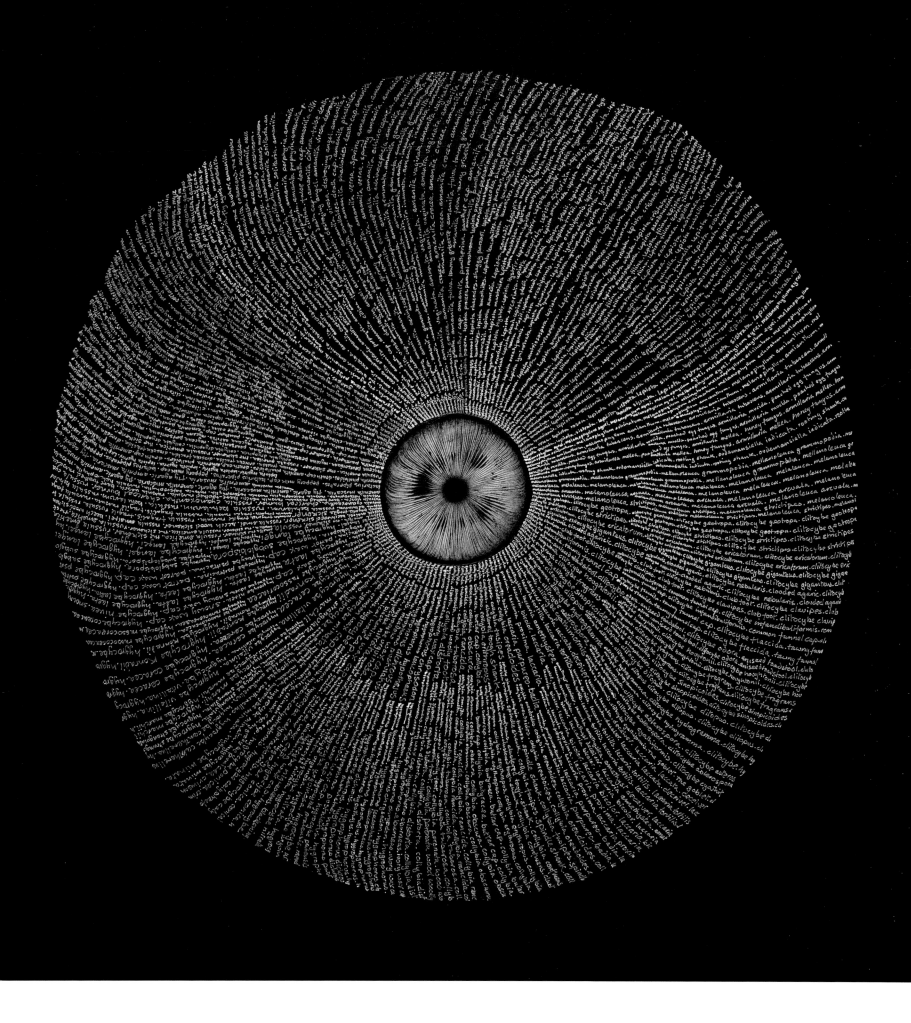

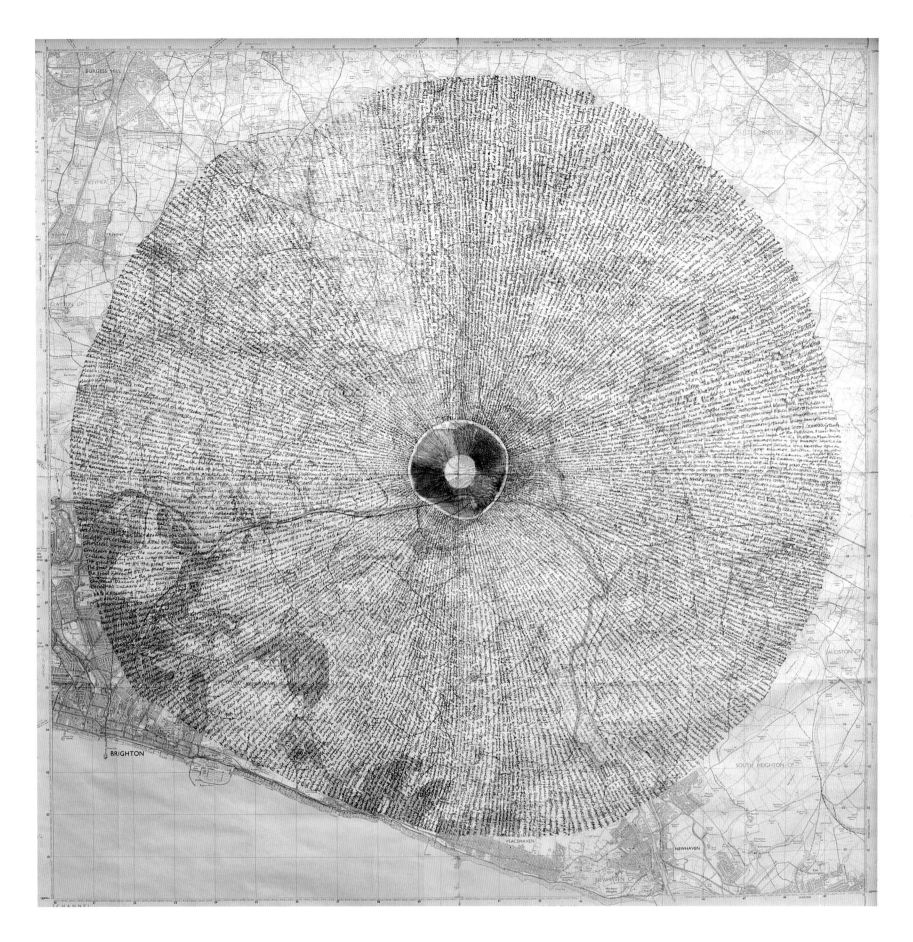

A DENSE HISTORY OF PLACE

spore print and text (personal reminiscences linked to the area) in ink

1996

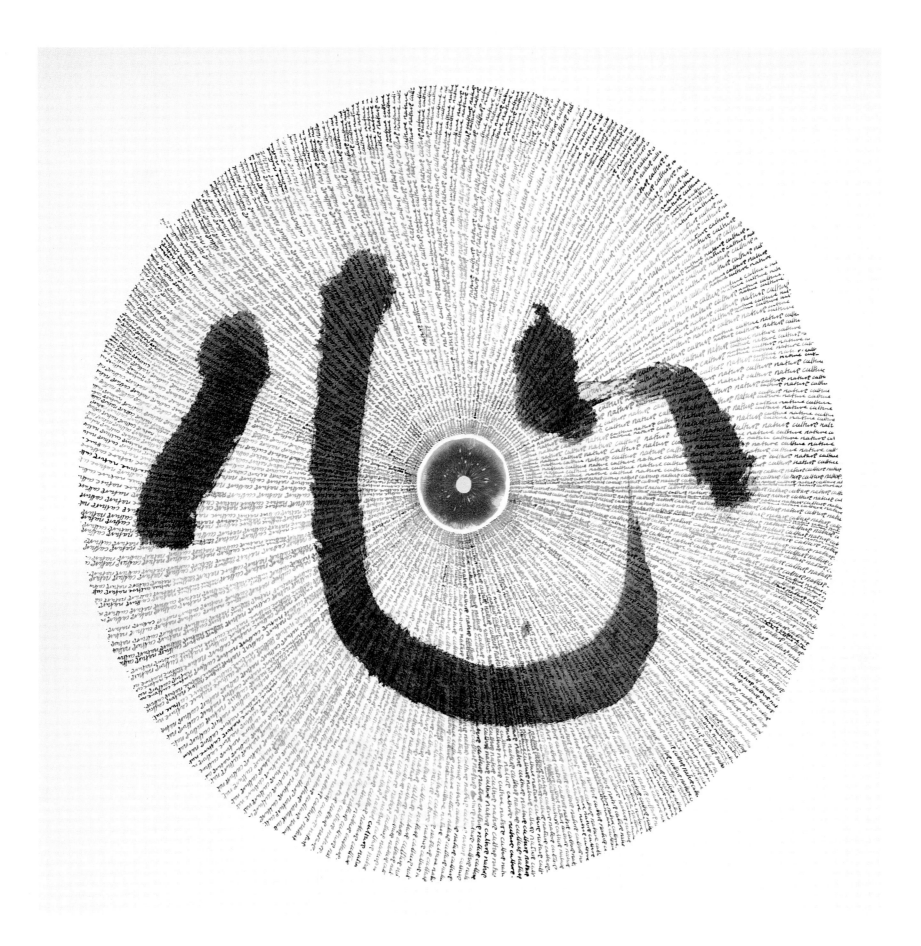

NATURE/CULTURE

spore print with words in rust ink overlaid with Japanese tissue paper and black ink (Chinese character *kokoro* means mind/heart/soul)

made in collaboration with Myojin Ok, 1998

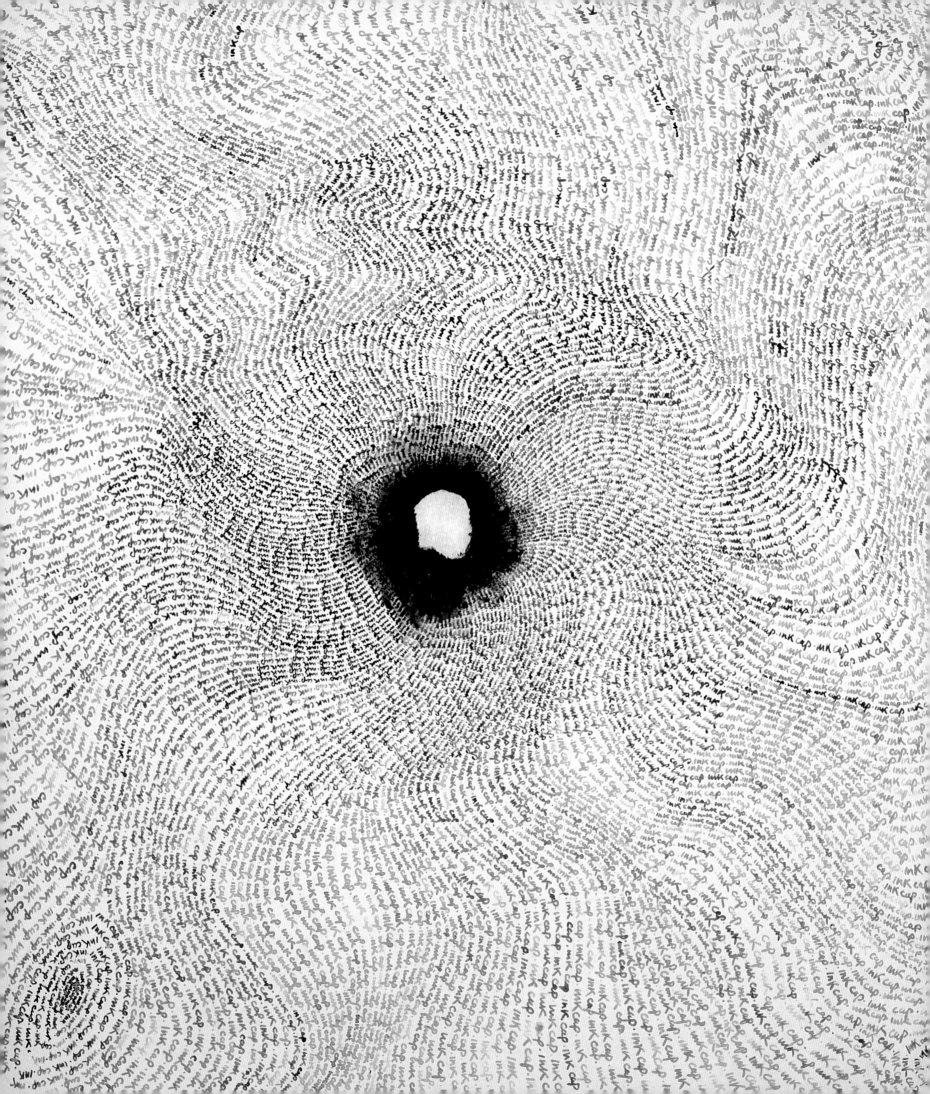

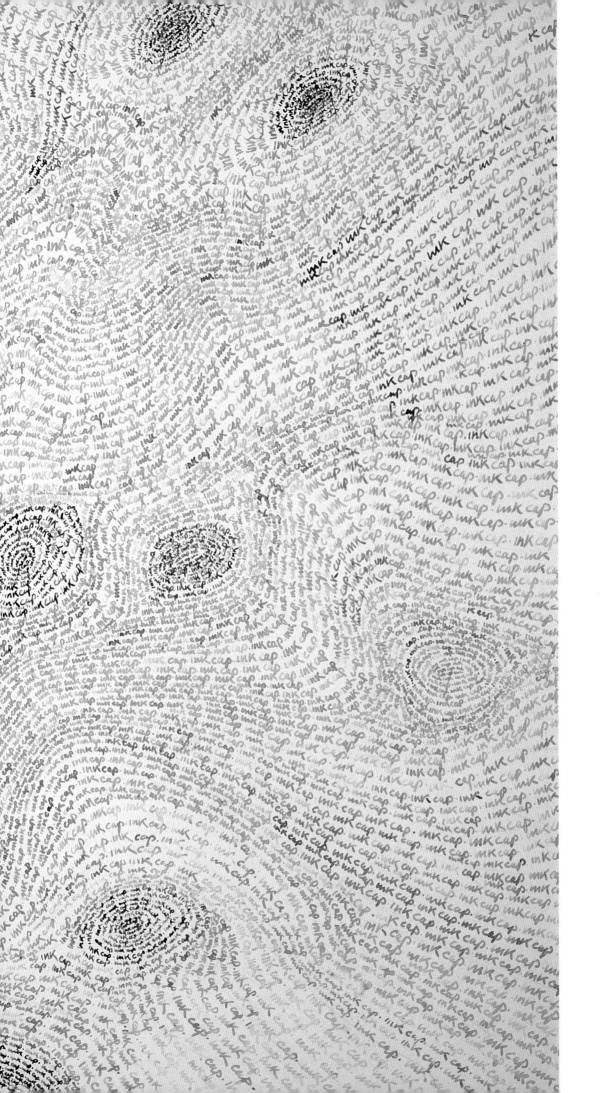

INK CAP II

Spore print and text in spore ink on card

1996

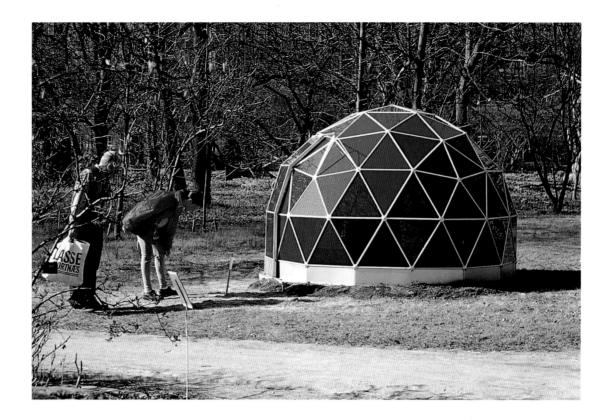

MIND WAVE

words scratched through blue paint
inside greenhouse

Botanic Gardens, Copenhagen, 1996

A wave does not in itself exist, it is a movement of water made by wind
Wind does not in itself exist, it is a movement of air
Mind itself does not exist, it is a movement of thought
When there is no wind, there are no waves on the lake, which becomes a mirror
 reflecting land and sky
When thought dies away, the mind is a mirror of the universe.

When I first visited the Botanic Gardens in Copenhagen, I quickly realised that you could describe the place as a living sculpture devised by botanists and gardeners. The whole has been carefully considered and controlled. I felt that any 'nature' sculpture here would be icing on the cake.

I immediately knew that I wanted to use contrasting man-made materials, but to work with a familiar form – the dome. An adapted geodesic dome greenhouse seemed to fit the circumstances. At the time I was preparing drawings and plans for a wave chamber at Kielder Reservoir in Northumberland, and the words 'wind' and 'wave' were in my mind. I wanted to turn these words into a three-dimensional version of the mushroom drawings, with radiating lines of text like the gills of a mushroom, allowing the outside (the gardens) to come into the dome as light and colour through the scratched words in the paint. The words for the drawing are:

WAVE-WIND/WAVE-MIND/MIND-WIND/WIND-MIND/MIND-WAVE/WIND-WAVE

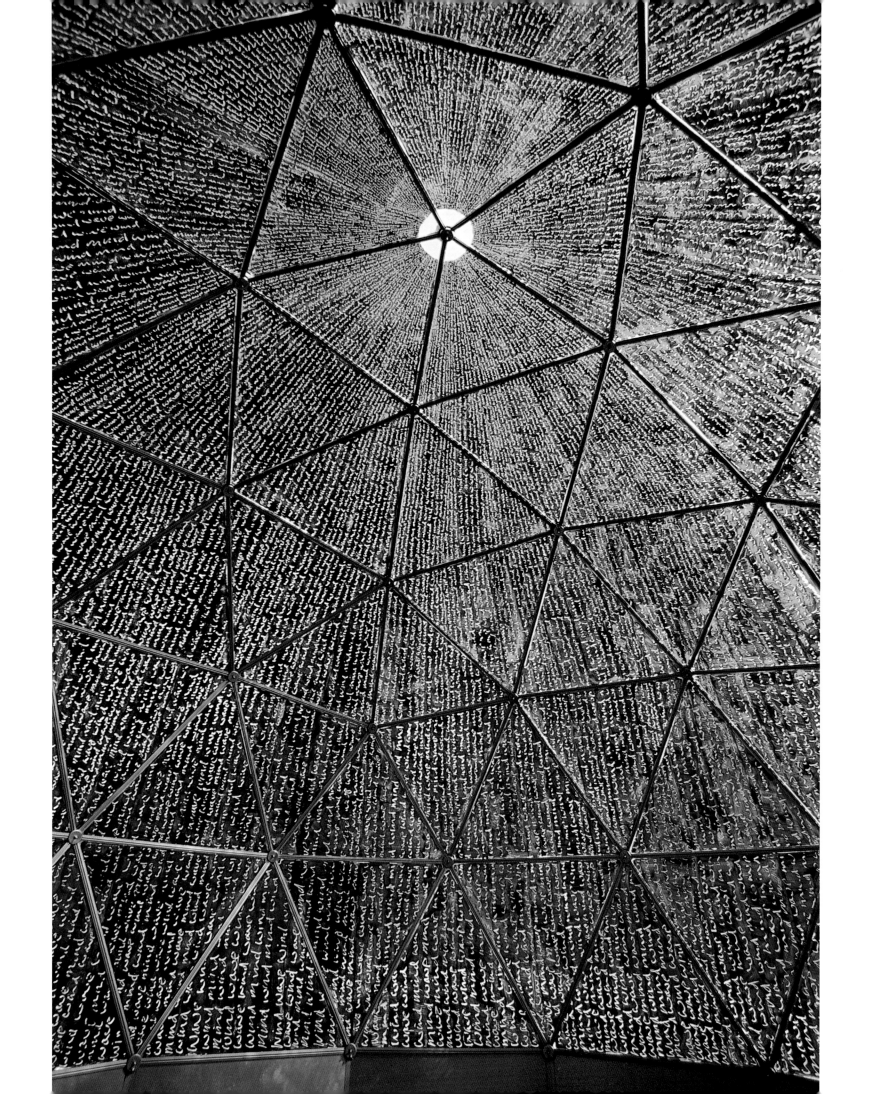

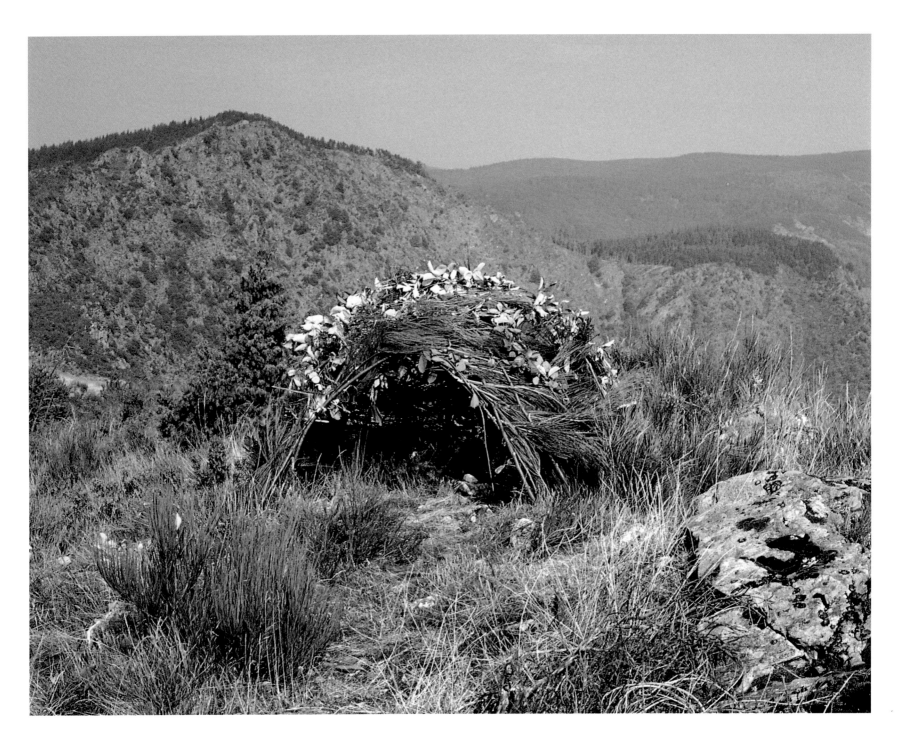

SHELTER FOR HERBS AND HEALING

branches from aromatic plants

Cévennes mountains, southern France, 1986

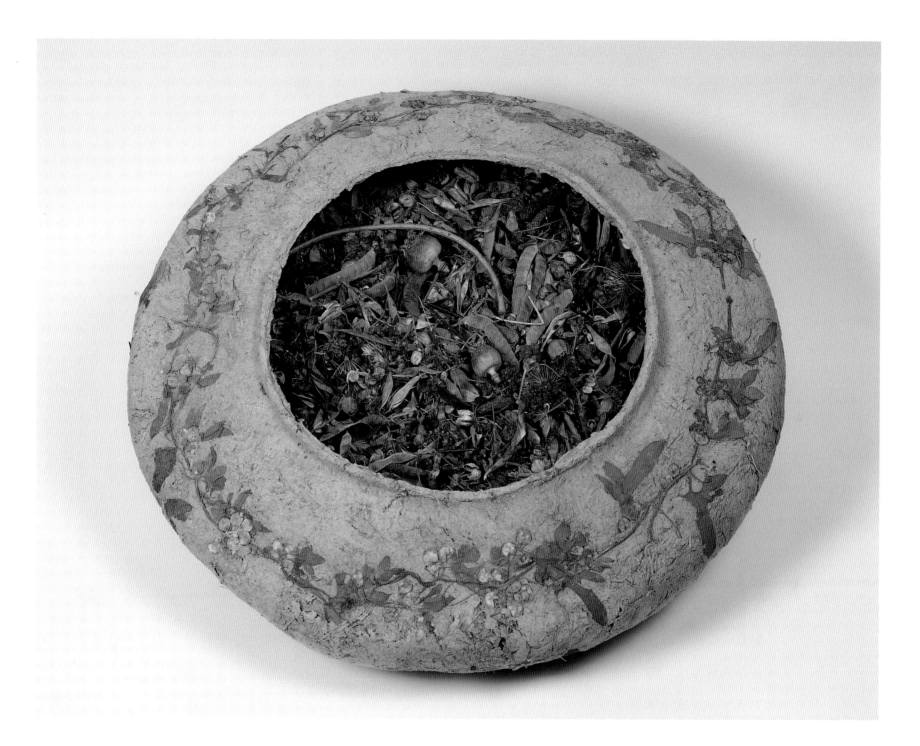

MEDICINE BASKET

plant pulp and the seeds, flowers and berries of fifty-six plants

1984

Angelica, bindweed, black bryony, bluebell, box, bracken, broom, burdock, cotoneaster, cowslip, cuckoopint, deadly nightshade, dock, dropwort, field mustard, foxglove, great burnet, heather, hellebore, hemlock, hemlock water dropwort, henbane, herb robert, hogweed, holly, iris, ivy, ladies bedstraw, laurel, tree lupin, mignonette, mistletoe, mugwort, hedge mustard, plantain, poppy, sea poppy, privet, purging flax, ragwort, sea spurge, sun spurge, sorrel, spindle, St John's wort, saxifrage, tansy, thorn apple, toadflax, traveller's joy, common vetch, viper's bugloss, wayfaring tree, woody nightshade, yellow rattle, yew.

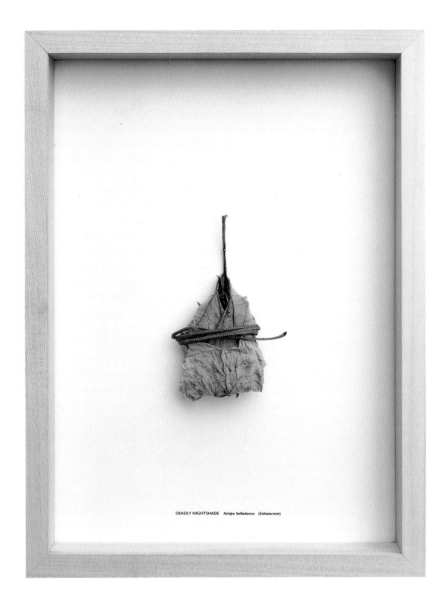

DEADLY NIGHTSHADE *Atropa belladonna* (Solanaceae)

HIDDEN AND REVEALED

deadly nightshade wrapped in burdock leaf, bound with willow bark,

one of nine burdock leaf bundles containing various plants, 1995

Opposite

PINE CIRCLE, CONE SPHERE

pine cones, pine bark, pine twigs and pine needles

1984

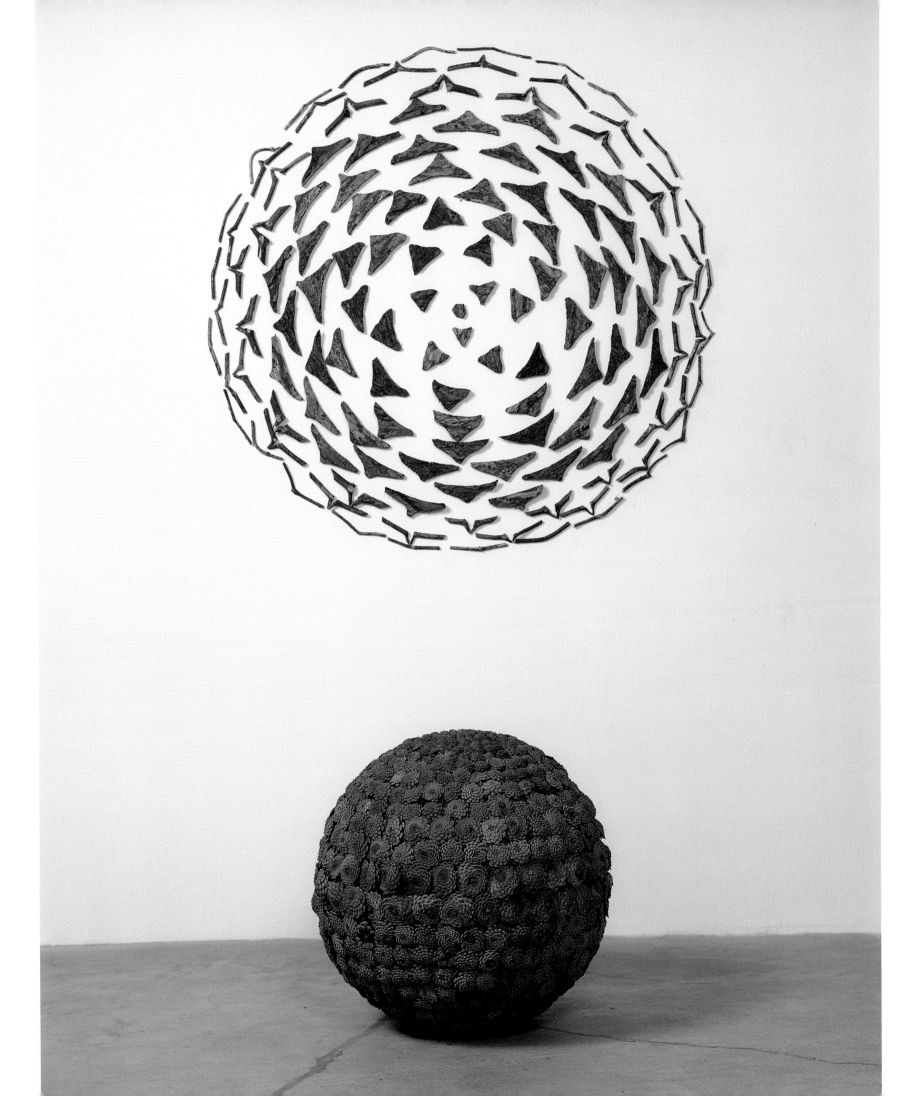

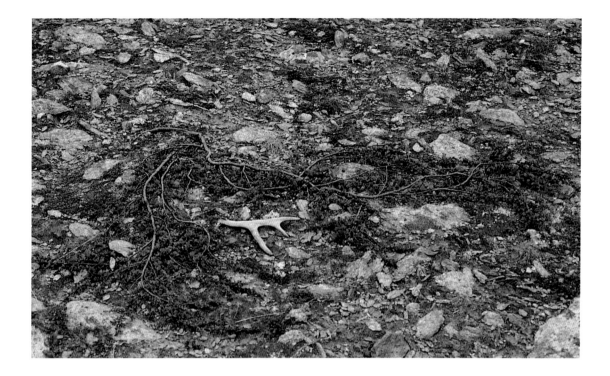

DWARF BIRCH

dwarf birch, birch bark, stone and willow

1988

The dwarf birch grows in extreme conditions, as here on a mountain top, way north of the Arctic Circle. This tree could be 300 years old. Further inland in sheltered places, like the one where I gathered the materials for the basket), it grows abundantly as a dense shrub 40 to 50 cm high, and the Saami use it green as an instant fire lighter. The basket's white birch-bark binding is in the shape of antler fragments which they use as drum sticks.

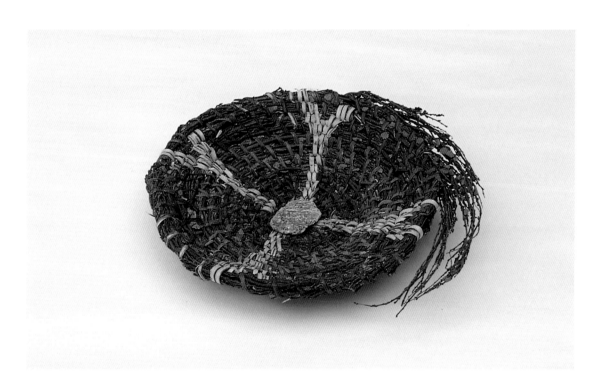

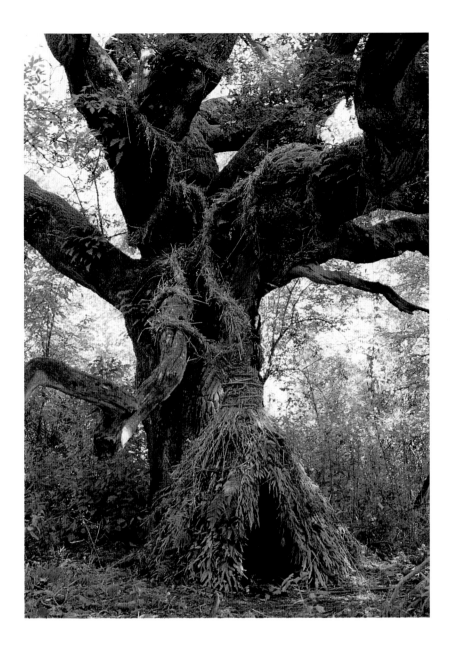

SHELTER FOR THE TREES

structure of branches thatched with rosebay willowherb;
rope of straw from nearby stubble fields

Sussex, 1989

BOUND OAK

rope of grasses

Sherwood Forest, Nottinghamshire, 1990

An old, dead oak tree wrapped with grasses, part of a work called Touching One Hundred Oaks, for which a single leaf was picked from each of one hundred oak trees; each leaf was then placed in a clear sachet with a hand-printed label, and all of these were enclosed in a hinged oak box.

The basket is made from the two extremities of trees: birch branches bound with pine roots. The design starts from the four cardinal directions, expands out and then back to their starting point. The design on the dewpond is the same but doubled, i.e. eight lines.

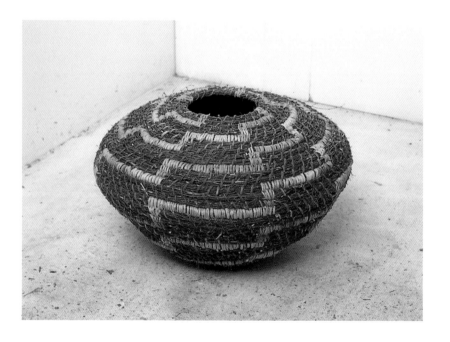

BASKET FOR THE TREES

birch twigs bound with pine roots

1988

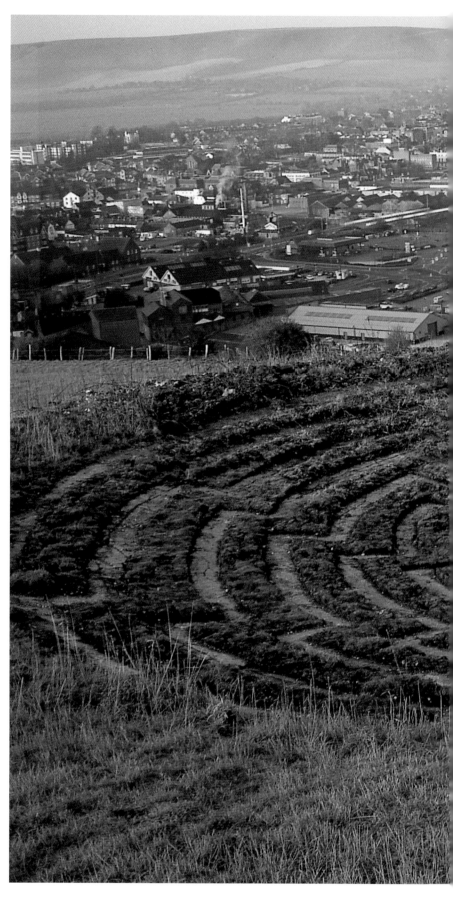

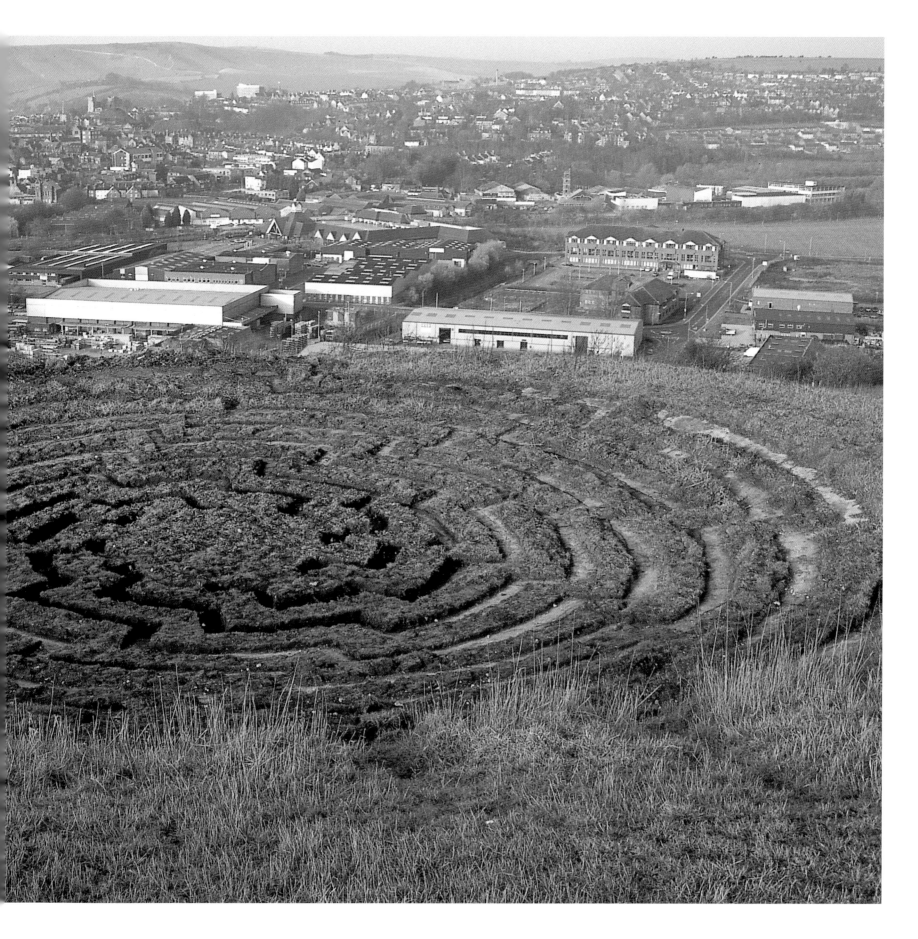

BASKET DEW POND

turf cut and moved with a spade

Malling Down, Sussex, 1997

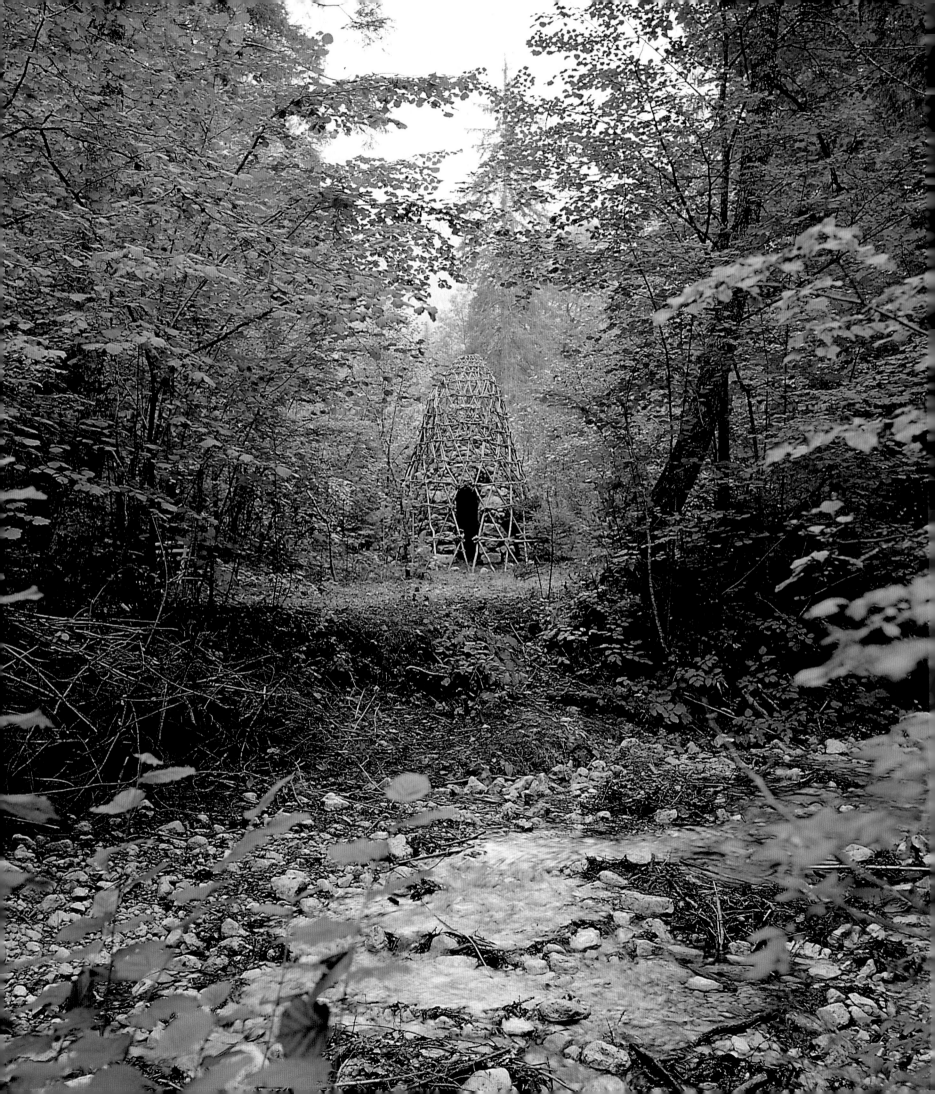

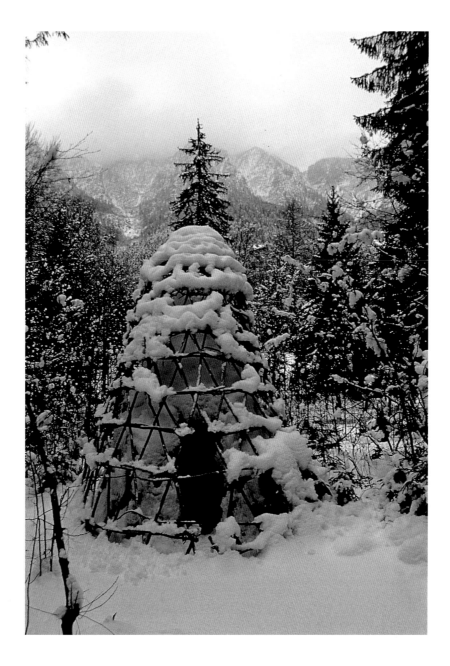

TREE MOUNTAIN SHELTER

hazel and stone

Casa Strobele, Sella valley, Italy, 1994

In the Sella valley, in northern Italy, you cannot see the mountains for the trees, but the mountains dominate the valley and attract its damp and stormy weather in summer and deep snow in winter. In many cultures the mountain and the tree symbolise the journey of the human psyche.

The work is placed on the only site with a view past the trees to the mountains. Shaped like a mountain, its inner, woven hazel shell is clad in stone, which in turn is surrounded by an outer, open-weave cover of sticks. In the side facing the mountains is a window. From here there is a view of the actuality of nature, the mountain, which nevertheless acknowledges human separation from it: nature viewed from the shelter of culture. You look out through wood, through stone, through wood again, past the lone standing pine to the mountain.

CLOUD CHAMBERS

I tried out the idea for the first cloud chamber in my small town garden. I made a frame with bent sticks, covered it with plastic and tarpaulins, cut an aperture about two centimetres in diameter in the top and placed a sheet of paper on the grass floor. It was a bright, sunny day with strong winds blowing white cumulus clouds across the sky. Inside I stared at the paper, waiting for my eyes to adjust to the dim light. All of a sudden the paper was blue, and stunning white clouds were drifting silently across it. I put my foot out and the clouds drifted across my shoe. It was what I had expected, but the sheer magical beauty of that silent moving image took my breath away. Every *camera obscura* I have made since has been a simple variation of that first tarpaulin shelter.

That summer (1990), I took the idea to Belgium for the biannual Beelden Buiten – an exhibition in a small walled garden in the town of Tielt. The shelter was built of woven local willow, plastered with clay. The small oval door was woven from reed, as was a circular roof which framed the aperture. The floor was plastered white. A week's work for two of us. At the opening of the exhibition, a journalist who had not yet been inside and who was anxious to understand the thinking behind this round mud hut asked if I was at all influenced by the art of Africa. Unhelpful as usual, I told him it was based on a Belgian chocolate.

I like the idea that you can enter these dark, earthy (sometimes underground) chambers, and in this quiet space see what is outside brought in and reversed. The cloud or sky chambers of Tielt in Belgium, Tyrebagger in Scotland and Okawa-mura, Japan, are all built from earth and trees. Inside these dark, earthy chambers, sited practically among the roots of trees, images of clouds and treetops appear – a reminder of the movement of water through roots to branch to cloud, as well as a metaphor for dark to light movement in human beings.

The cloud chamber built in the gardens of St James's Church, Piccadilly, one of the busiest and noisiest parts of London, was made from a woven frame of hazel, clad with stone. It was a temporary, easily dismantled shelter made from sandstone. These gardens are an oasis of peace in a busy city, used as a refuge by homeless people and by office workers at lunchtime as a place to picnic. The work here was a practical and political statement (as was the accompanying fire cairn/bread oven), and also offered a focus of mindful calm in the mindless rush of daily city life. Of course this is only an illusion of calm, as a quiet meditative space does not guarantee a quiet mind. In life all is movement; only the mind holds the possibility of being still.

These *camera obscura* works, particularly those built from stone, are among the few permanent works I have made outside. The sheer physical labour of building one in three weeks is a massive but enjoyable task, as many people become involved. It is particularly rewarding when the works are made in small communities, such as Kielder in Northumberland, Okawa-mura in Japan, Lochmaddy on the Scottish island of North Uist. Skills are shared, time and labour offered free, friendship and laughter generated. Always it is hard work.

For me, building cloud chambers is a strange process. There is the frenetic and often stressful activity of planning and constructing, usually with a tight deadline. At the end I may be lucky enough to have a free day to take photographs and enter into the stillness of what has been created. Inside this stillness is an ever-changing vision of movement.

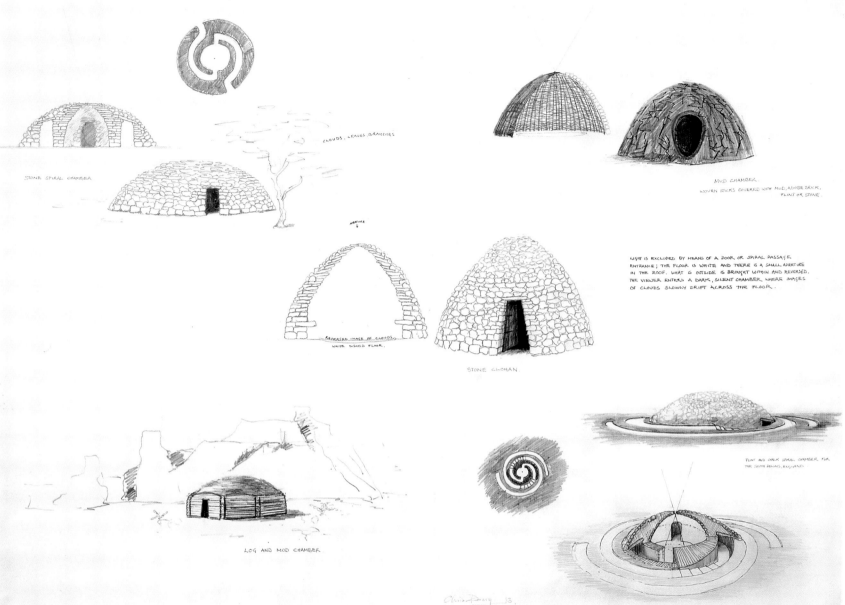

CLOUD CHAMBER DRAWINGS

pen, ink, pencil on paper

1993

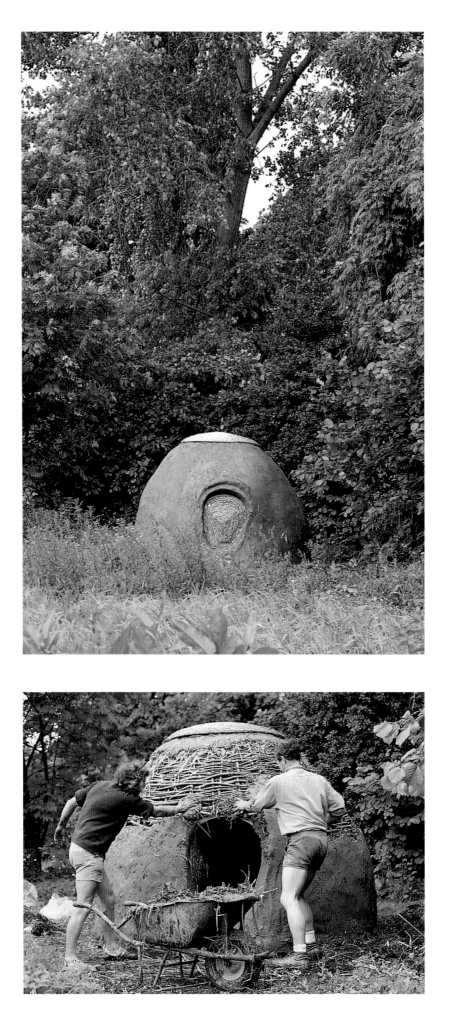

CLOUD CHAMBER

willow structure daubed with mud,
top and doorway made of reeds

Beelden Buiten, Tielt, Belgium, 1990

110

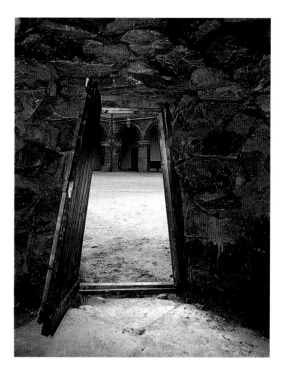

CLOHAN CLOUD CHAMBER

stone, wood

Dublin, 1992

Below

FIRE CAIRN/BREAD OVEN

stone and bricks daubed with London clay

St James's Garden, Piccadilly, London, 1993

Below and far left, bottom

CLOUD CHAMBER

hazel structure clad with stone

St James's Garden, Piccadilly, London, 1993

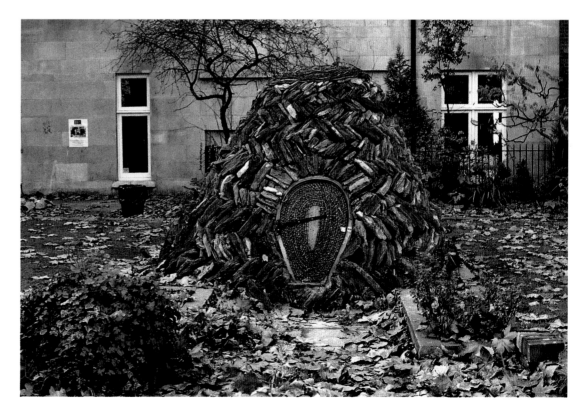

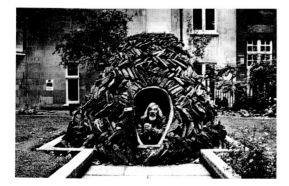

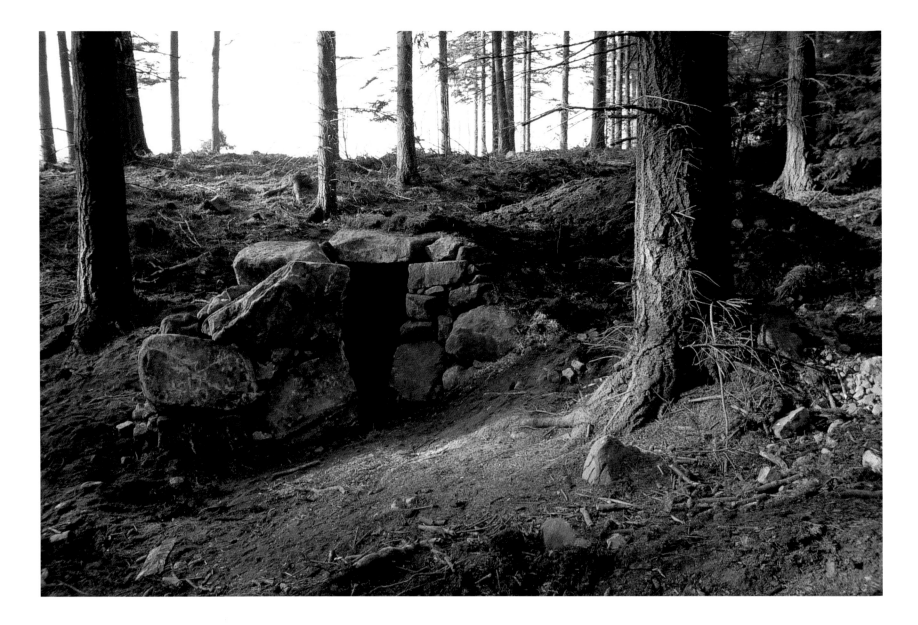

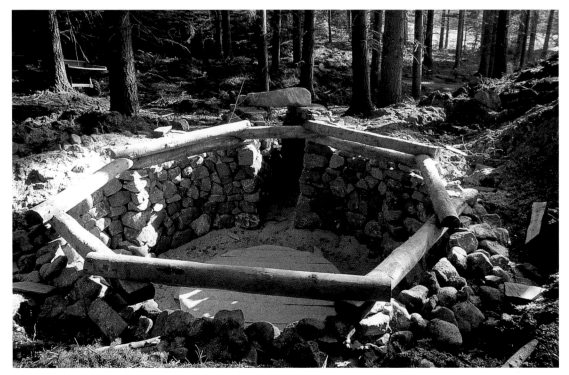

EARTH CHAMBER
FOR THE TREES AND SKY

stone walls, log roof covered with earth

Tyrebagger Forest Project, Kirkhill Forest, Aberdeenshire, 1994

This view is what you see inside the chamber, projected on to a floor made of longitudinally split logs, which are arranged pale side up. (The projected image itself is too delicate and flickering to be caught in a still photograph.)

CEDAR LOG SKY CHAMBER

stone foundations, structure of cedar logs, thatch of cedar bark, glass, lens

Okawa-mura, Kochi Prefecture, Japan, 1996

pen and ink drawing

1996

Tuesday 8th November 1996

1.30 am Woken by pouring rain outside. Realised that rain causes landslides. Rockslides plus earthquakes means that people here do not build with stone – too dangerous. Spent next four hours drawing and thinking. I have to use wood on stone – as it is in the landscape. Here there are four elements: sky, clouds, rock and forest. The forest is like an ephemeral skin, a fragile but vital part of the cycle that produces clouds and rain. Therefore the Cloud Chamber should be built from trees. I will use cedar logs on a rock foundation. I will cover it with a thatch of cedar bark so it is soft like the fur of an animal.

Wednesday 16th November 1996

Raining and cold. Get to Cedar Log site at 9.00 am when rain stops – beautiful white clouds with clear light. We mark and cut logs, it takes ages. Syunsuke is an expert – when he is here, the work goes fast. He has little use for words. His attention is always focused.

Syunpachi makes a rice offering to the trees before he cuts them. The wild pigs will eat this rice tonight. Mr Yasumatsu says that Mr Kawamura will eat the wild pig next month. I like this ritual: I hope it protects Syunpachi from some terrible accident. He is somewhat reckless with the chainsaw, but a wonderful worker. I am superfluous for the moment, so after lunch I go down the mountain to work on the Fire Mountain Cairn. Yasumatsu turns up and helps. We set off for home as darkness is falling.

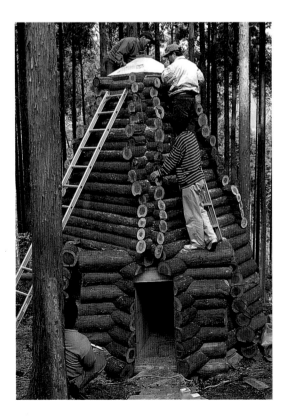

114

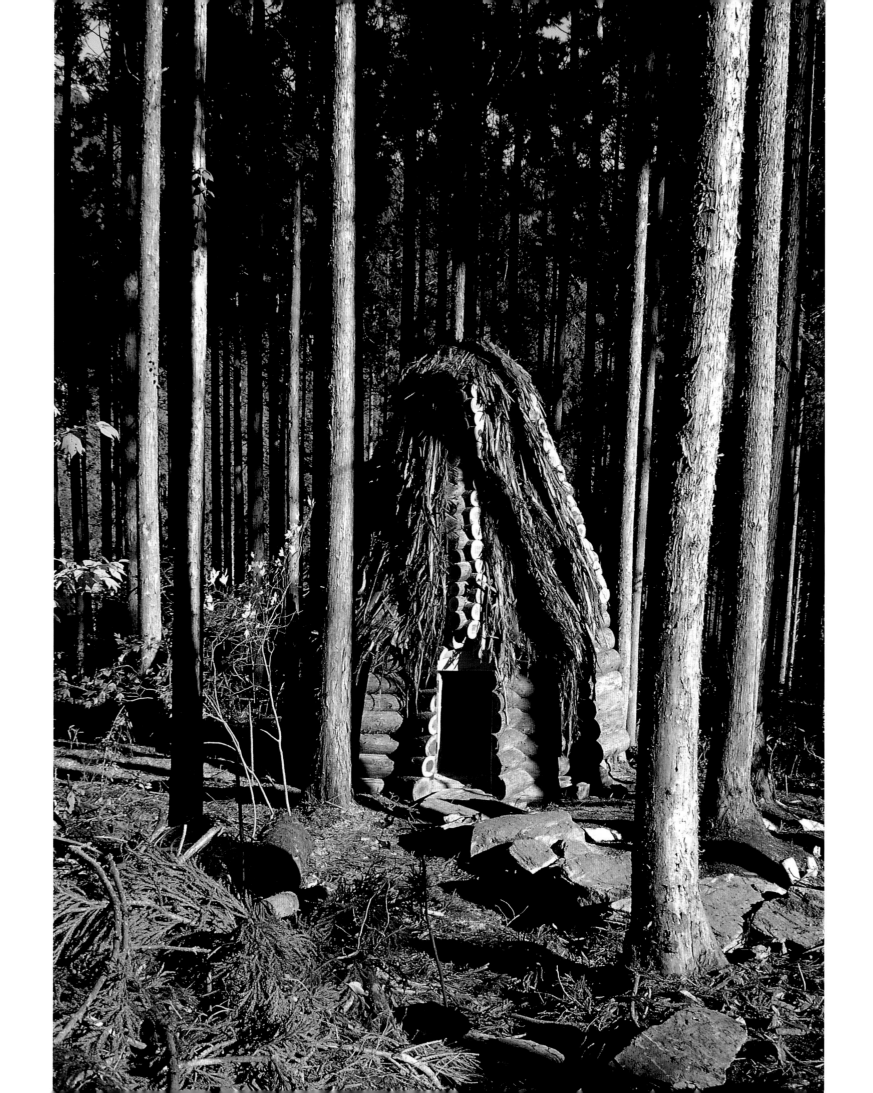

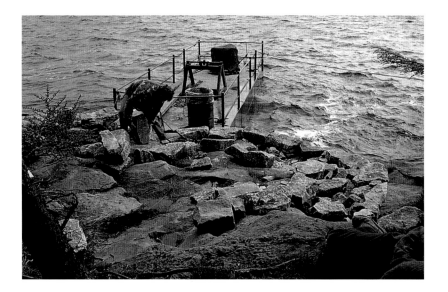

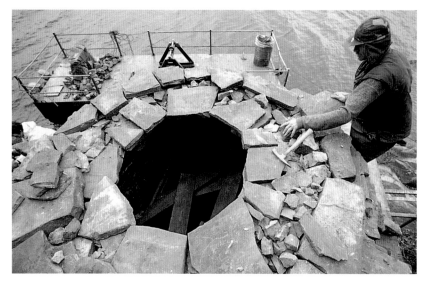

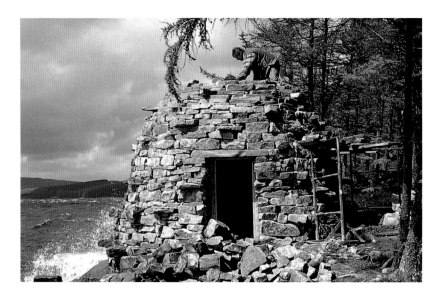

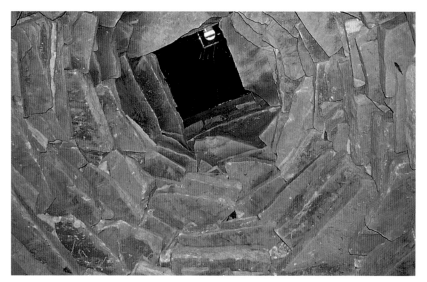

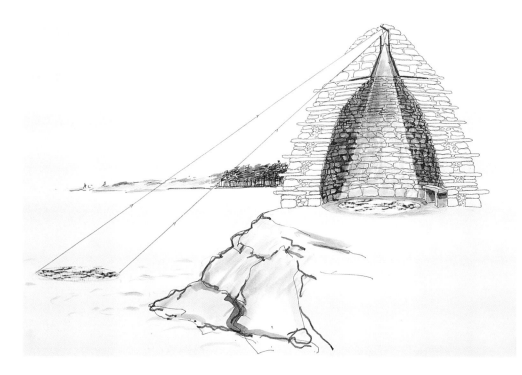

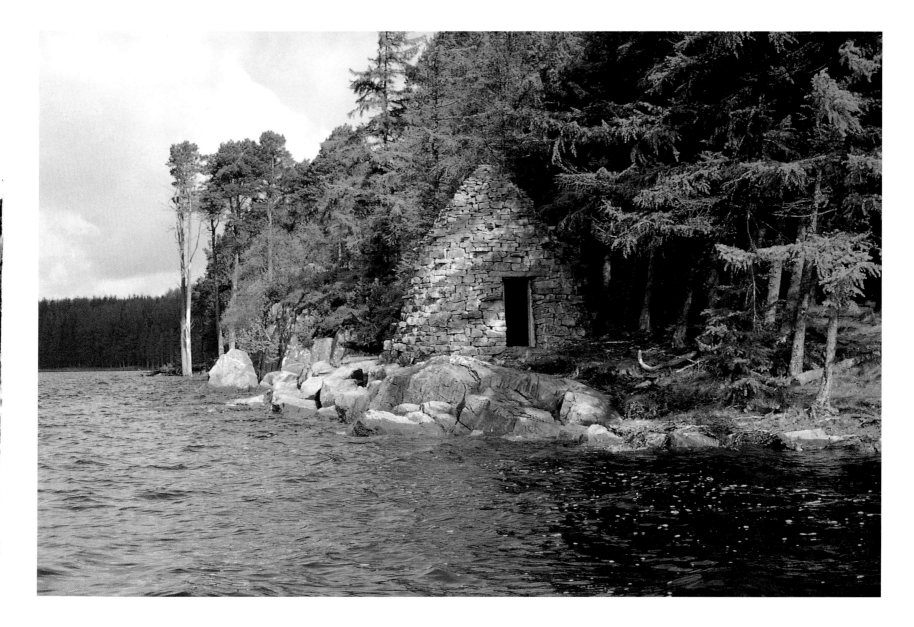

WAVE CHAMBER

dry-stone with mirror and lens in a steel periscope

Kielder Reservoir, Northumberland, 1996

At Kielder, because of my stubbornness in wanting to build the work in the most beautiful but inaccessible place, all the rock had to be transported to the site by barge. The stone was taken off old, broken walls in the forest by hand, loaded on to a truck and dumped at the nearest accessible spot on the reservoir, then loaded by hand on to the barge, sailed to the site, unloaded by hand, often in screaming winds and five-foot waves, and finally built into the walls of the chamber.

It was a last-minute idea to try to cast an image of waves on the floor by using a steel periscope with mirror and lens built into the top. Rough drawings had been scribbled during telephone conversations with Comar Optics in Cambridge. The periscope was welded up at the garage in Kielder, and we nearly lost it when it all but fell out of the boat after the outboard stalled as we tried to land in huge waves. I really didn't know if it would work until the point when we put the door on and the inside went dark. At that moment the afternoon sun was hitting the water just where the mirror was angled. Inside it was as if a thousand silver coins were dancing across the floor. As the sun moved away, this changed to ghostly ripples, giving you the feeling of standing on liquid. There are times here when it is grey and blowing a gale and the lens mists over with rain, then nothing is visible, and you are left with the amplified sound of waves crashing on the rocks outside.

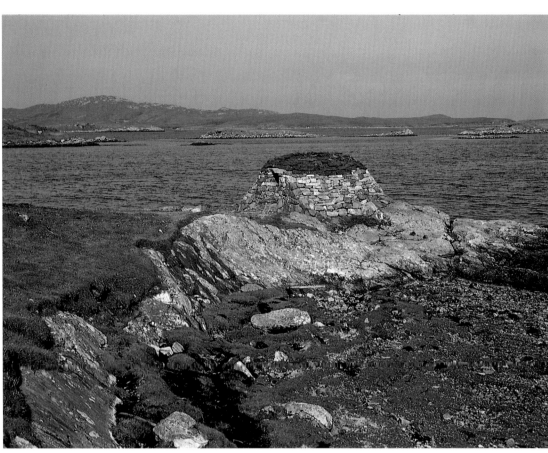

HUT OF THE SHADOW/
BOTH NAM FAILEAS

dry-stone walls, timber and turf roof, mirrors, lens

Lochmaddy, North Uist, Western Isles, 1997

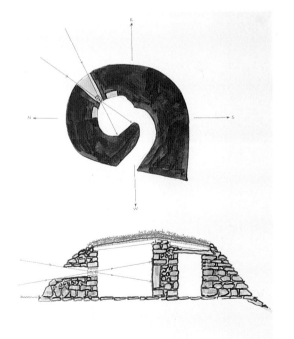

People who have never experienced being inside cloud chambers sometimes question the difference between looking up at clouds (or down at the water) and seeing the image inside a chamber. In fact, these experiences are quite distinct. At Lochmaddy, for instance, you can see the same landscape projected inside as you can when you stare out at the islands, but it is an altered image, slightly blurred, dim, like a scene from an old movie or a dream. One woman said it disturbed her, that she couldn't quite believe it was the same view, it was more like a memory from her childhood – a 'soul-catcher'.

Acknowledgements

There are many people I would like to thank for their help and support over the years without which the work in this book might never have come into being. In particular, all members of my family, Krysia Drury, Harriet Leppan, Bill Nicholson for letting me use his beautiful barn, and Robin Noscoe. For walks along the way, friendship, good conversations and crazy times, thanks to: Alfio Bonanno, Cormac Boydel, Alan Counihan, Patrick Dougherty, Hamish Fulton, Tsering Gurmet, Michael Munday, Paul Nesbitt, Eiji Okubo, Herman and Vera Prigann, Helge Røed, Tashi Stobden and Kay Syrad.

For advice, exhibitions and funding: Clive Adams, Liliana Albertazzi, The Arts Council of England, Joeg Bader, Siuban Barry, The British Council (in particular, Takeshi Sakurai and Peter Thomson), Les Buckingham, the Beelden Buiten committee (in particular, Antien Knaap and Griet de Sauter), James Bustard, Bob Chaplin, Douglas Chrismas, Tom and Laurie Clark, Common Ground, Simon Cutts and Coracle, Zina Davis, Gillian Dunne, Dr Terry Friedman, Catriona Grant, Charles Hall, Rebecca Hossack, Penny Johnson, Margaret McAnallan, Declan McGonagle, Jette Dahl Møller, The Henry Moore Foundation, Graeme Murray, Paul Nesbitt, Paul O'Reilly, Hannah Peschar, The Pollock Krasner Foundation Inc., Barry Prothero, David Reason, The Scottish Arts Council, South East Arts and many other regional arts associations and local authorities, The Sculptors Society of Ireland, Penny Thomson, David Tseklenis, Nicholas Usherwood, Alistair Warman and Arthur Watson.

For all those people who set up, funded and ran projects: Robert Breen and Juliet Dean from Art in Partnership, The Arte Sella Committee (in particular, Charlotte Strobele and Emanuele Montibeller), Carol Buchan, Forest Enterprise, Syunpachi Hata, Louise Holloway, Yoshitami Kawamura, Geoff King, Kochi Prefectural Government, Eiji Okubo, Rachel Parry, Alex Perry, Sandy Sandilands, Sustrans, The Taigh Chearsabhagh committee (in particular, Anna Davis, Norman and Margaret Johnson, Anne Mackenzie, Norman Macleod, Donald and Helen MacDonald and Fiona Pearson), The Tickon Committee (in particular, Alfio Bonanno and Gertrud Købke Sutton), Alessandro Vincentelli and Takeshi Yasumatsu.

For help with projects: Walter Bailey, Roger Bamber for his photographs, Garry Beschoff, Simon Beaujie, Seamus Campbell, Sue Chaplin, Hugh Court, Sava Ebisawa, Don and Gavin Golden, Juliet and Jeremy Keyte, Tom Macaulay, Michael McShane, Hakushi Maeda, Satori Motokasu, Hiroko and Ok Myojin, Nuka, Mie Okimoto and the gang of students from Kyoto Institute of Technology, Martin Sullivan, Barny Riley, Tanabe Syunsuke, Dan Tomas, Mr Toyota, Andy Wood and all the many, many other people who gave their time and energy for free.

For their technical help and advice: Comar Optical Components, Bruce Cowan from Solardome Industries and Danny Holloway. For education projects: Brian Ball, Stuart Frost, Ian Howard, Ian Hunter and Celia Larner, Helen O'Donoghue, Deborah Rawson, Chris Thomas, Philip Turney and David Wood.

Finally, thanks to Kay Syrad for our many searching conversations and for her unstinting support, and to Jill Hollis and Ian Cameron for their belief in the work, their attention to detail and all the long hours, international flights and the incredible work they have done to make this book what it is.

Directions

Long Vessel Watergrove Reservoir, Wardle, Lancashire (p.25)
Ordnance Survey Landranger map 109: 90.5 longitude/18.6 latitude
Park in the first car park at Watergrove Reservoir, walk through the gate and along the road which runs north, parallel to the reservoir wall, to the sailboard club. Take the marked footpath that leads through the small gate to the left of the main cobbled path and follow it through the wildflower meadow. Cross the bridge over the feeder stream and turn right. At the second stile, bear left up the steps through a gate and up the hill. 50 metres on, at three thorn trees, leave the path and walk 100 metres straight up the hill. From a distance, the work looks like a large dry-stone wall. 30 minutes walk each way.

Beara Shelter Wilderness Sanctuary, Allihies, West Cork, Ireland (p.32)
One mile from Allihies on the Eyeries road. Inquiries to telephone/fax 00 353 277 3085

Earth Chamber for the Trees and Sky Tyrebagger Forest Project,
Kirkhill Forest, Aberdeenshire (pp.112-113)
Ordnance Survey Landranger map 38/Aberdeen: 85.5 longitude, 10.9 latitude.
Take the A96 Inverness road out of Aberdeen. Go past the airport on the right. After two miles, turn left on to B979 which immediately enters Tyrebagger Forest. Park at the visitor car park and follow the circular trail The work is in the south-east corner, just off the trail, under some large Douglas fir trees.

Cedar Log Sky Chamber Okawa-mura, Kochi Prefecture, Japan (pp.114-115)
The work is situated high up the mountain just off a forest road. Ask at Okawa-mura village office for directions.

Wave Chamber Kielder Water, Northumberland (pp.116-117)
Ordnance Survey Landranger map 80/Cheviot Hills and Ordnance Survey Explorer map 1/Kielder Water: 69. 5 longitude, 88.3 latitude.
At Kielder Water, drive across the dam and park in Hawkhope car park. Follow the north shore waymarking to the first peninsula, called The Belling. Cross the isthmus on to The Belling and follow the circular path to the most southerly point on the Belling crags. The work is just east of the crags at the water's edge, near a trig point and information board. 30 to 40 minutes each way.

Hut of the Shadow Lochmaddy, North Uist, Western Isles (pp.118-119)
Ordnance Survey Landranger map 18: 92.4 longitude, 69.5 latitude.
Follow the road from the Ferry Pier past Taigh Chearsabhagh Art Centre on the right. Take the first road on the right opposite the village shop. Fork left past the youth hostel and take the second right past the Stag Lodge guesthouse. Walk on past the outdoor centre where the road becomes a track leading to a suspension bridge. Cross the bridge on to the piece of land called Sponish. From the bridge, you can see the work on the first small peninsula. 20 to 30 minutes walk from Taigh Chearsabhagh Art Centre.

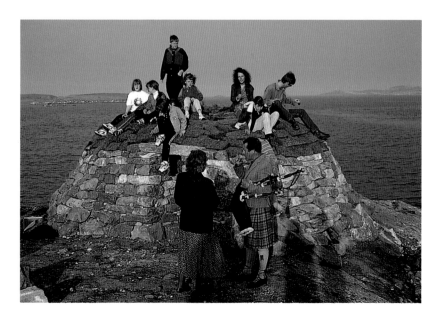